Alexander
the Great

Alexander the Great

From His Death to the Present Day

JOHN BOARDMAN

Princeton University Press

Princeton and Oxford

Copyright © 2019 by Princeton University Press

Published by Princeton University Press
41 William Street, Princeton, New Jersey 08540
6 Oxford Street, Woodstock, Oxfordshire OX20 1TR

press.princeton.edu

LCCN 2018935462
First paperback printing, 2021
Paperback ISBN 978-0-691-21744-4
Cloth ISBN 978-0-691-18175-2

British Library Cataloging-in-Publication Data is available

Editorial: Ben Tate and Hannah Paul
Production Editorial: Sara Lerner
Text and Cover Design: Carmina Alvarez
Cover Credit: From Charles le Brun (1619–90), *The History of Alexander*, woven
silk and wool tapestry (297.0 × 229.0 cm) showing Alexander the Great entering
Babylon. Blenheim Palace, Woodstock. Photo by Julia Boardman.
Production: Erin Suydam
Publicity: Jodi Price
Copyeditor: Jay Boggis

This book has been composed in Garamond Premier

Printed in the United States of America

Contents

CONTENTS

Some talk of Alexander
And some of Hercules
Of Hector and Lysander
And such great names as these.

The British Grenadiers' marching song places Alexander the Great at the head of famous military commanders of both myth and history. The British Army has also always found a place in its heart for the Spartan Lysander, who defeated the Athenians—but perhaps he was included in the song because he rhymed with Alexander. Hercules, a demigod rather than a soldier, and Hector, an epic Trojan prince, but killed by Achilles, were powerful figures of Greek myth/history, although not as successful as the mortal Alexander in terms of world conquest. The nearest divine match for such a hero was the Greek god Dionysos (Roman Bacchus), who earlier had been said to have travelled much the same path to the east, even to India, in his role of persuading the world of the importance of wine, and wielding the cup rather than the sword.

The early eighteenth-century soldiers' song goes on:

Those heroes of antiquity
Ne'er saw a cannonball
Or knew the force of powder
To slay their foes withal.

"Alexander" means "protector of men" rather than "destroyer," and this, together with our hero's reputation, made it popular not only in antiquity, but more recently as a name for Russian and German emperors, even popes, for rulers rather than generals (other than General Alexander in North Africa, facing Rommel). In Britain we have recently celebrated the royal christening of Prince George Alexander Louis of Cambridge, while our recurrently popular politician Boris Johnson's first name is Alexander.[1] But today Soviet Russian ballistic missiles are called by Alexander's eastern name—Iskander.

[1] He told me that he attended my Greek Sculpture lectures in Oxford, my only Alexander connection, other than my good friend, Professor Alexander Cambitoglou, in Sydney but first met in Athens.

Abbreviations

AWE: *Ancient West and East* (Leiden: Peeters)

Boardman, *Diffusion*: J. Boardman, *The Diffusion of Classical Art in Antiquity* (London: Thames and Hudson, 1994)

Bosworth/Baynham: A. B. Bosworth and E. J. Baynham, *Alexander the Great in Fact and Fiction* (Oxford: Oxford University Press, 2000)

Chugg, *Lovers*: A. Chugg, *Alexander's Lovers* (Bristol, 2006)

Chugg, *Quest*: A. Chugg, *The Quest for the Tomb of Alexander the Great* (Austin, Texas: AMC, 2007)

Fraser, *Alexandria*: P. M. Fraser, *Ptolemaic Alexandria* (Oxford: Oxford University Press, 1972)

JHS: *Journal of Hellenic Studies* (London)

Lane Fox, *Alexander*: Robin Lane Fox, *Alexander the Great* (Camberwell, Victoria: Penguin Books, 1973)

Lane Fox, *Search*: Robin Lane Fox, *The Search for Alexander* (Boston: Little, Brown, 1980)

Nigg, *Beasts*: Joseph Nigg, *The Book of Fabulous Beasts* (New York: Oxford University Press, 1999)

Ogden, *Alexander*: Daniel Ogden, *Alexander the Great, Myth, Genesis and Sexuality* (Exeter, UK: University of Exeter Press, 2011)

Prabha Ray/Potts, *Memory*: H. Prabha Ray and Daniel Potts, eds., *Memory as History: The Legacy of Alexander in Asia* (New Delhi: Aryan Books Int., 2007)

Rapelli, *Symbols*: P. Rapelli, *Symbols of Power in Art* (Los Angeles: Getty, 2011)

Ross, *Studies*: D.J.A. Ross, *Studies in the Alexander Romance* (London: Pindar Press, 1985)

Saunders, *Tomb*: N. J. Saunders, *Alexander's Tomb* (New York: Basic Books, 2006)

Search: *The Search for Alexander, an Exhibition* (Washington, DC: National Gallery, 1981)

Stewart, *Faces*: A. Stewart, *Faces of Power*. Hellenistic Culture and Society, 11 (Berkeley: University of California Press, 1993)

Stoneman, *Greek*: R. Stoneman, *The Greek Alexander Romance* (London: Penguin, 1991)

Stoneman, *Legends*: R. Stoneman, *Legends of Alexander the Great* (New Haven: Yale University Press, 1994, repr. 2012)

Stoneman, *Life*: R. Stoneman, *Alexander the Great: A Life in Legend* (New Haven: Yale University Press, 2008)

Stoneman et al. 2012: *The Alexander Romance in Persia and the East*, ed. R. Stoneman, K. Erickson, and I. Netton (Groningen: Backhuis, 2012)

Veloudis, *Alexander*: D. Veloudis, *Alexander der Grosse. Ein alter Neugrieche*. Tusculum Schriften (Munich: Heimaran, 1969)

Yalouris: N. Yalouris, "Alexander and His Heritage," in *The Search for Alexander, an Exhibition* (Washington,DC: National Gallery, 1981)

Zuwiyya, *Companion*: Z. D. Zuwiyya, *A Companion to Alexander Literature in the Middle Ages* (Leiden: Brill, 2011)

Alexander
the Great

Introduction

The reader should be warned that my story (rather than "study") is only very marginally devoted to the real Alexander, but is almost wholly concerned with stories told about him after his death, both about "historical" events and, especially, the fantasy that scholars and poets have woven around him from antiquity down to the present day, from ancient and mediaeval "Romances" to modern film. His name and career have been "used" by authors, historians, and artists, relentlessly. They take us over a very full range of European and eastern literature and art, from Scotland to China, as well as of geography, since the whole of the Old World was deemed to have been the setting for his adventures, especially Asia. In the latter case, what I write depends rather little on personal experience of the eastern areas described (certainly not the imaginary ones, as yet) although I have tourist-travelled Iran, Afghanistan, Uzbekistan, Turkmenistan, Pakistan, north India, Ceylon, and China. My principal written sources are those I have abbreviated, and the many cited in footnotes, and which I have found in the Sackler Library in Oxford or via Abebooks. I should note especially my debt to Richard Stoneman for his many books published on the Romance aspects of the subject over the last twenty-odd years and his comments on what I have written. George Huxley and Paul Cartledge also

kindly read a late draft of my text and offered many useful corrections and additions, as have others, notably Olga Palagia. Claudia Wagner has been exceptionally helpful in the preparation of the text and references to academic sources. But the reader will also surely be aware of my plundering of the Internet, verified where I could. So I would not claim this as a work of original scholarship, except in its assembly, but I hope it will appeal to some scholars unfamiliar with this area, somewhat removed from real history yet reliant upon it as well as upon the imagination of numerous writers and artists, east and west. It also has, I believe, a certain entertainment value. It is the product of a desultory but fairly thorough skimming of many different sources, an activity that has given me much pleasure, which may be, I hope, in part shared by the reader, if for no other reason than that the possibilities of expanding it seem endless. The evidence and sources are confusing, like the stories themselves, and I cannot deny having added somewhat to the confusion. Nor would I claim for this any degree of "completeness." I find new references daily, but there had to be an end.

Alexander the Great lived in the fourth century BC, a Macedonian, born in Macedonia, the country at the northeast of the Balkan peninsula, abutting onto the Black Sea, neighbour to Illyria, Thrace, and other immigrant states. The Macedonians were remotely related to the Greeks, who had made their way to the south of the peninsula much earlier, from the sixteenth century BC on, becoming our "Mycenaean" Greeks. The Macedonians too were "Indo-Europeans," and spoke a language related to Greek (as well as to much else that hailed distantly from the "Indo-

European" east), if not always mutually intelligible in our period. They were a single nation with a royal family, unlike the Thracians' petty kings, the Illyrians and other neighbours, and unlike the Greek-speaking tribes who had preceded them, by a considerable time, moving eventually to the south of the peninsula and beyond—south (Crete, Mycenaeans destroying the Minoan civilisation) and east (Anatolia and fighting Troy). By the fourth century BC the Macedonian kings had decorated palaces, built royal tombs, and were dependent on Greek arts and probably Greek artists, as was much of the eastern Mediterranean world by then. I suspect that they were temperamentally most like the Romans, also Indo-Europeans, who might have gone west into Italy at about the same time as the Macedonians entered the Balkans. Greece of our period was very different: dozens of independent cities—some democracies—of sorts, with an occasional local king or "tyrant" for each "city-state." They never united until forced to by others and then selectively, and "Hellas" signified a common race and language, not a common government. In the Bronze Age, they had been ruled from a group of independent fortified Greek citadels (like Mycenae and Pylos), and in the "historic" period, any "empires" they formed (e.g., the "Athenian") were short-lived, limited, and on home ground. On occasion, some (not all) could collaborate against a foreigner (Persians, Lydians), but they rated profit from foreign contacts more highly. They spent a lot of time fighting each other.

Alexander was no democrat. It was said that his father had enlisted the Greek philosopher Aristotle (also a northerner, born at Stagira) to educate his son, a fact not revealed to us until sources of the first century BC/AD, but generally

3

accepted, although to some degree implausible except to those dedicated to Alexander's Greekness. But Aristotle had moved to Athens, and he had to be summoned back for the tutoring, and he never mentions his "pupil" in his plentiful extant works. He was said to have had to return south to found his School in the Lyceum in Athens in 355 BC. The philosopher plays a prominent part only in many of the less historical and fantasy stories of our man, even accompanying him to the east. By now it might seem almost sacrilege to doubt Aristotle's historical role, but. . . .

So I still call Alexander "Macedonian" not "Greek," for his upbringing, royal undemocratic background, and behaviour, whatever some of his genes may have been (some no doubt also shared with the Indo-European Romans). There is plenty of evidence for his attitude to Greeks, fighting some (destroying Thebes), despising others, even killing those who had been prisoners of the benign Persians and resettled by them in Persia after the Persian Wars. On his march east, he sent home the Greek contingent, employing only some mercenaries, and he married only easterners. He seems not to have spoken the Greek vernacular but, allegedly, could read Greek (Homer).

Alexander's reputation and adventures, real and imaginary, have caught the attention of the whole western world and even much of the east, down to the present day. My subject here is the mythical (and dead) Alexander and the way he has been treated by authors and artists since antiquity—not "real" history, therefore, but an attempt to share with the reader much that I and others have found interesting, amusing, and even instructive, about the legacy of the great man, about the image that he projected for posterity

and the way his story could be used for social, political, or artistic ends. In many respects, though, it tells as much or more about the attitudes and interests of those who have written about him or depicted him, and their often remarkable inventiveness and readiness to ignore the truth (inaccessible to most of them). We find that one imaginative story can generate many more. Also, since Alexander travelled far, he is the excuse for many a travelogue, real or imagined.

Alexander's successful conquest of the Persian Empire in the fourth century BC, reaching even beyond it to as far as India, was certainly the major military exploit of antiquity before the Romans created their empire, mainly over far less civilised lands and peoples; apart, that is, from the Greeks and the Carthaginians (ex-Phoenicians). His new, but short-lived, empire was not simply a replacement of the Persian but the start of an expansion of the Mediterranean world (then Greek, basically), and not simply a deliberate destruction of all that seemed Persian. This perhaps made him easier for many Persians to accept. But as an Alexander expert, Brian Bosworth, put it, "For large areas of Asia the advent of Alexander meant carnage and starvation and the effects were ultimately as devastating as that of the Spaniards in Mexico. The conquerors created a desert and called it empire" (Bosworth/Baynham, 49). But he also brought the benefits of a different civilisation to stand beside the Persian, and profoundly transformed the civilisations of Central Asia and India.

His skill as a military commander is indisputable. To a modern student of generalship, he was "Heroic," while Wellington was an "Anti-Hero," General Grant "Unheroic,"

and Adolf Hitler "False Heroic."[1] His quality as a man can raise some questions. His expedition was allegedly to wreak revenge on the Persians for their sack of Athens in the early fifth century BC, although the Persians had been defeated by Athens both before (at Marathon) and after (at Salamis and Eurymedon). Alexander himself, we have remarked, was not a Greek. In the years just before the start of his great expedition east, Philip, his father, and Alexander himself, had fought and defeated recalcitrant Greeks, who could never get their act together against any aggressor (not even the Persians initially), and were severely punished by the Macedonian kings for their independent ways and words (generally those of Athenian orator-politicians like Demosthenes). But they had prestige of a sort denied the Macedonians (briefly vassals of the Persians in 480), for their stand against Persia in the fifth century BC, for their heroic past (the Trojan War and Homer), and for their obvious (to many) intellectual skills. At any rate, the men of Macedon were empire-builders in a way the Greeks could never be. What Greeks sought was *Lebensraum* and riches, not power. The Persians were the most obvious quarry for the Macedonians.

Philip had intended to invade the east but was assassinated. His son followed his father's ambition, but both had been busy defeating Greeks in these years. When Alexander marched east, there were a few Greeks in his army, mostly mercenaries from the mainland.[2] Others who went with him were soon sent home, and there were more Greeks in the Persian army, from their provinces (satrapies) in Asia

[1] John Keegan, *The Mask of Command* (London: Penguin, 1987).
[2] On Alexander's army, see N. Sekunda, *The Army of Alexander the Great* (London: Osprey, 1984).

Minor (Anatolia) and mercenaries, than in Alexander's. We learn of his history from Greek writers, and often our sources were written long after the events. As Greeks, they betray a certain uneasiness about Alexander's attitude to their ancestors, torn between truth-telling and a proper regard for his achievements. There are of course modern problems too about "Greek" Macedonia between the states. A "spirits medium" (Stephen Hermann) has conjured up an Alexander who urges the modern citizens of Macedonia to accept reconciliation. The Former Yugoslav Republic of Macedonia naturally has an interest in keeping Alexander away from too much idolatry as a "Greek." They may have a point historically, but erecting statues of Alexander and issuing stamps with his image will not go far enough to dispel the "Greekness," which Alexander himself fostered. In neighbouring Albania the early fifteenth-century hero George Castriotis took the name Scanderbeg (= Alexander), and there is a public equestrian statue of Alexander in Tirana, as also in Bulgaria, in Sofia. We shall meet more of Alexander in the Balkans.

There was something superhuman about the man, and soon after his death stories were circulating about his life and afterlife, which drew heavily upon existing legends of the mysterious east. Whether he was truly exceptional, physically or intellectually, is a matter for dispute. Some have thought him an epileptic (the "sacred disease"); others that he suffered from the lasting effects of concussion. He was certainly fond of the bottle. His image remained truly iconic to the present day—witness recent films, and there has long been a mystic quality about him—even association with Christ in that both died at the alleged mystic number

of years—thirty-three. This book is devoted to a selection of the stories about Alexander that were invented and circulated after his death, and to the ways he has been treated by authors and artists ever since. As an introduction to them I quote from an early passage in one of the most readable scholarly accounts of Alexander's life of recent years, by Robin Lane Fox:[3]

[3] Lane Fox, *Alexander*, 26. I use this as a major source for the man since it is thorough, well based on both ancient sources and personal knowledge of the terrain involved, and it is engagingly written. His *Search* is more accessible for the general reader and very well illustrated. There are many books about Alexander. Early modern scholars tended to dwell on the aspects of empire-building, as befitted the age of modern empire-building, as Droysen and Grote (see *Memory*, ch. 7). There are very many modern works, tending to the repetitive but often with a message not unrelated to contemporary events, whether admitted or not. P. Cartledge's *Alexander the Great: The Hunt for a New Past* (London: Pan, 2011) is reliable, succinct, and thoughtful. There are A. B. Bosworth's excellent chapters in *Cambridge Ancient History*, vol. 6 (Cambridge: Cambridge University Press, 1994) and his other books. W. W. Tarn's *Alexander the Great* (Cambridge: Cambridge University Press, 1948) is a useful and terse, somewhat idealising account of his life and influence. I. Worthington, *Alexander the Great, Man and God* (Harlow: Pearson Longman 2004) has a good chapter (14) about Alexander's view of himself as a god. N.G.L. Hammond's *The Genius of Alexander the Great* (London: Duckworth, 1997) is the fruit of years of study of the classical and Hellenistic Greek world. J. D. Grainger's *Alexander the Great Failure* (London: Hambledon Continuum, 2007) is about his life, as are most of the essays in *Alexander the Great: A New History* (eds. W. Heckel, L. A. Tritle; Oxford: Wiley-Blackwell, 2009). An excellent brief study of all aspects of our subject is by the French scholar C. Mossé, *Alexander, Destiny and Myth* (Edinburgh: Edinburgh University Press, 2004). French scholars have been particularly busy with Alexander books in the last fifty years. The internet is a valuable resource: there is an "Alexander the Great Bibliography" site by Dr. Martin Cuypers; "Alexander the Great on the Web"; "Pothos.org". For the Persian Empire, there is a useful account of sources in L. Llewellyn-Jones, *King and Court in Ancient Persia 559–331 BCE* (Edinburgh: Edinburgh University Press, 2014); A. Kuhrt and S. Sherwin-White, *Hellenism*

[Alexander's name] attracted the youthful Pompey, who aspired to it even in his dress; it was toyed with by the young Augustus, and it was used against the Emperor Trajan; among poets Petrarch attacked it, Shakespeare saw through it; Christians resented it, pagans maintained it, but to a Victorian bishop it seemed the most admirable name in the world. Grandeur could not resist it; Louis XIV, when young, danced as Alexander in a ballet; Michelangelo laid out the square on Rome's Capitol in the design of Alexander's shield; Napoleon kept Alexander's history as bedside reading, though it is only a legend that he dressed every morning before a painting of Alexander's grandest victory. In Egypt he was said to have visited the empty sarcophagus that had held Alexander's body and intended to take it to France.

Through the continual interest of the educated west in the Greek past, and through the appeal, mostly in oriental languages, of legendary Romances of Alexander's exploits, his fame reached from Iceland to China: the Well of Immortality, submarines, the Valley of Diamonds and invention of a flying machine are only a few of the fictitious adventures which became linked with

in the East (London: Duckworth, 1987). Most recently there are essays in *East and West in the World Empire of Alexander:. Essays in Honour of Brian Bosworth* (eds. P. Wheatley and E. Baynham: Oxford University Press, 2015). He figures in my *Persia and the West* (London: Thames and Hudson, 2000). In "Recent Travels in Alexanderland" *JHS* 134 (2014): 136–148, H. Bowden is fazed by the recent spate of Alexander publications, and see his *Alexander the Great: A Very Short Introduction* (Oxford University Press, 2014). A Mythalexandre Project has been launched in France, available at http:/mythalexandre.meshs.fr.

his name. When the Three Kings of the Orient came to pay homage to Jesus, Melchior's gold, said Jewish legend, was in fact an offering from Alexander's treasure. Because of the spread of the *Romance of Alexander*, there are Afghan chieftains who still claim to be descended from his blood. Seventy years ago they would go to war with the red flag they believed to be his banner, while on stormy nights in the Aegean, the island fishermen of Lesbos will shout down the sea with their question, "Where is Alexander the Great," and on giving their calming answer, "Alexander the Great lives and is king," they rest assured that the waves will subside.

Most literature about Alexander is laudatory, even enthusiastic, without concealing his human weaknesses and errors. Some express a shade of skepticism about whether he deserves this "Greatness." Recently an attempt has been made to redress the balance a little in favour of the Persians, which seems fair since the Persian Empire was one to admire among all those of antiquity—an admiration shared by Greek writers before Alexander's day—Herodotus and Xenophon—whatever Greeks may have thought about the eventually abortive Persian invasion of their country in the early fifth century BC, and especially of their sacking of Athens. Thus Darius III, the Persian emperor for whom Alexander himself eventually found some sympathy—once he was deserted by his followers—rightly finds still a champion in a French scholar, Pierre Briant, a true expert in all matters concerning the Persian Empire.[4]

[4] *Lettre ouverte à Alexandre le Grand* (Arles: Actes Sud, 2008) and *Darius in the Shadow of Alexander* (Cambridge: Harvard University Press, 2015);

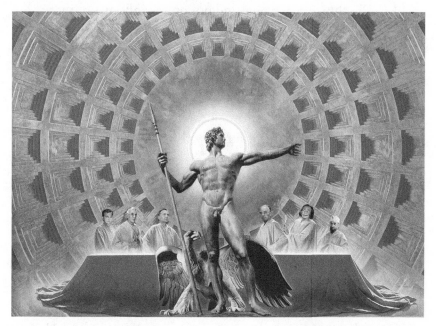

FIGURE 1. P. Peyrolle, "The Last Supper of Alexander." © Pierre Peyrolle.

Enthusiasm for the man seems to have re-emerged in the twentieth century, allegedly inspired by ancient practice, and promoted by King Paul I of the Greeks, in an "Order of Alexander the Great" to reward and promote progress in Arts and Sciences. Reputed recipients are given honorary titles and the French impressionist/surrealist artist Pierre Peyrolle (1945–) painted for it a splendid "Last Supper" of Alexander with some of his modern honoured guests (fig. 1). Evidence about the "Order" is obscure.

This book contains an account of several of these legends and attitudes to Alexander, from antiquity to the present

and a wider view of Alexander in *Alexandre des lumières* (Paris: Gallimard, 2012). *Alexander the Great: The Heroic Ideal*. New Horizons (London: Thames & Hudson, 1996).

day. The choice is personal and not quite random, but there are some subjects and stories that appeal more to a classical scholar and his sense of humor (or history). The "Alexander Romance" is an especially important source, or rather sources since there were very many different versions which were created in the late classical and near eastern world, Coptic, Christian, and Islamic, with resonance from Scotland (the *Buik of Alexander*), to Ethiopia, to Malaya (as Iskander Zulkarnain) to China. There were also apocryphal collections of his letters—to his mother, Olympias, about Egyptian gods, and to Aristotle about India. He was to be the subject for songs, operas, plays, films, cartoons. But we start more seriously with his ancient biographers, mainly Greeks, who were not altogether impervious to the appeal of the many adventures imagined for the man by storytellers and writers, some invented even during Alexander's life-time.[5]

[5] F. Jacoby's *Fragmente der griechischer Historiker* (now Brill: Leiden, 1923–) has a volume devoted to the Alexander historians.

I

His Biographers

Several contemporary scholars, courtiers, and writers who knew Alexander, and some of whom even accompanied him to the east, wrote histories of his exploits. These have survived only in fragments quoted by later historians. From them we can glean some idea of historical events, but also the nonhistorical ones, as well as much that was generated by prejudice for or against their subject. All these historians have been usefully discussed by Lionel Pearson in his *The Lost Histories of Alexander the Great*, a Monograph of the American Philological Association of 1960.[1] An even fuller account of these sources is an Indian scholar's, Professor U. P. Arora's *Greeks on India, Alexander to Megasthenes*. He favours Arrian, as do most. The sources are legion. I dwell especially on two authors who depended on and quoted these sources—Plutarch and Arrian—writing long after the events—and I am guided by Pearson initially for an account of their own sources. Diodorus Siculus, writing at the turn of the era, I largely ignore, since surviving work by him is rather summary, although he had "decent" sources, which were used by other ancient historians, and will be quoted where needed in later chapters. Curtius, writing in

[1] See also Fraser, *Alexandria*, ch.10.

Latin in the first century AD, had good sources and seems sometimes to offer a reliable account of them for the truth about Alexander.

Contemporaries

Callisthenes of Olynthus (in northernmost Greece) was related to the philosopher Aristotle. He accompanied Alexander in his travels east and wrote an enthusiastic commentary on them. This is lost, but it was used by later historians freely and must have been an invaluable first-hand account, at least until the point at which he fell out of favour with his master, and was executed. There was violence even in such academic aspects of our story. Callisthenes was a sophist, with a wide range of scientific interests, but also very much a Greek at heart and capable, therefore, of being critical of his subject and master. Much of his work informed the studies by later historians, but it is not easy to distinguish exactly what. Much later, "Pseudo-Callisthenes" is the name given to the author(s) of early Alexander Romances, non-historical, of the third century AD and later.

There were other historians contemporary with the great man, some of whom also accompanied him on parts of his expedition. They too are known only from fragments and quotations. From Egypt, Ptolemy, a fellow-student of Alexander's, was with the expedition and eventually, it seems, had much to do with the treatment of Alexander's body. Of Greeks, Aristoboulos was on the expedition, and with Alexander in India, and Nearchos was deeply involved in the last stages of Alexander's journeys (bringing home the fleet) and wrote an account of the Indian Ocean; and there was One-

sicritus, a philosopher companion. The second-century BC Greek historian Polybius has much to say about Alexander's relations with Greeks.[2]

The contributions of these contemporaries, with the later Polybius, can be added to the accounts written by later authors, but we cannot readily distinguish which were the most influential sources, for instance, for the treatment of Alexander's body after his death. Here I shall remark only on Curtius' account, but dwell more on only two of the later authors—Plutarch, the indefatigable and imaginative biographer of many a notable ancient figure, and Arrian, a more serious historian, who seems to have been properly critical of his sources. Here I simply pick out from their work passages which reveal their attitude to Alexander, his origins and behaviour, since these reflect well enough contemporary views, whether based on fact or fiction, and can give us some idea of how later antiquity, indeed down to today, was persuaded to view the Alexander story. I dwell especially on those more miraculous episodes, which may have gone to help promote the wholly fanciful Romances of later years.

CURTIUS

Curtius, writing in the first century AD, had good sources and seems sometimes to offer a reliable account of the truth about Alexander, but equally for the record of several of the more fanciful stories. Thus, he readily accepts Alexander's meeting with Amazons in and beyond the Caucasus, and their queen Thalestris, who fell passionately in love with him and wished to give him heirs—the boys for him, girls

[2] R. Billows, "Polybius and Alexander," in Bosworth/Baynham, ch. 10.

for her.[3] Her passion took thirteen days to be fulfilled. Amazons do not exist but it is possible that this does record an encounter with a nomad people and its female warrior leader (a role acceptable in the nomad world of Central Asia). This role is one that it has taken a long while for scholarship to acknowledge, despite Herodotus. Curtius also alludes to Alexander's interest in Meroe, in the Sudan.[4]

PLUTARCH

Of the authors who wrote about Greek history in general and Alexander in particular in the three centuries after his death, we have only scraps preserved in later writers. The adulation is apparent as well as a degree of acceptance of some of the more fanciful stories about his life and especially his birth. For a complete surviving work we have to wait for the Greek Plutarch, writing in the first half of the second century AD. He was a prolific writer, on philosophy as well as on aspects of the everyday life of Greeks and Romans. His *Parallel Lives* presented pairs of outstanding men from both backgrounds, consecutively, without always drawing specific parallels—certainly not in the case which concerns us—his *Lives of Alexander and Caesar*—beyond the obvious parallel that they were both world-beaters. For the most part, in describing Alexander's travels and adventures, he faithfully follows and quotes earlier historians, but he is ready to accept some more fanciful events that had been devised to enhance the appeal of the hero-king. So, he looks for "the signs of the souls of men," leaving to others

[3] On Thalestris, see A. Mayor, "When Alexander Met Thalestris," *History Today*, Jan. 2015, 11–17.
[4] Cf. Stoneman, *Life*, 136–138.

their great deeds and victories (*Alex.* 1). For him there is no question that Alexander was in the lineage of Hercules and, on his mother's side, of Aeacus, a son of Zeus/Jupiter himself. His mother Olympias lay with snakes as she slept, and her husband Philip dreamed that he saw her with a seal on her womb with the figure of a lion upon it. The snake connection he explained by the queen's devotion to the rites of Dionysus/Bacchus, prevalent in the north (Thrace, more than Macedonia). Zeus Ammon in Egypt and the Delphic oracle were also involved, and Alexander was born on the day the Temple of Artemis at Ephesus was burnt to the ground—which might be true. The snakes and Ammon will prove to be recurrent features.[5]

Plutarch presents Alexander as an intellectual as well as a warrior. He could deal harshly with the Greek city of Thebes, but he felt for Greeks, and was glad to lead them to the east. Indeed, his policy can be seen as Pan-Hellenic, whatever his treatment of many Greeks, given his esteem for Greek ideals, if not altogether for the Greeks themselves.[6] Plutarch has him meeting Diogenes in his tub, an encounter where the sage simply asked him to get out of the sunlight, a jibe that he took well, and this became a popular subject for artists after antiquity, but at Delphi he bullied the priestess of the oracle into declaring that he was invincible (*Alex.* 14). At Troy he saw the heroic relics but spurned the offer of Paris' lyre, preferring that of Achilles, on which he had sung the deeds of heroes.

[5] A choliambic poet knows how Ammon begot Alexander, disguised as a snake: *Theophrastus* (Loeb) Anon. II, p. 280.
[6] M. Flower, "Alexander the Great and Panhellenism," in Bosworth/Baynham, ch. 4., (96–135)

The account of the campaigns is largely anecdotal, well supplied with stories such as that of Hercules stretching out his hand to him from the walls of Tyre (*Alex.* 24). In Egypt, the Ammon oracle addressed him "*O paidion*" = "O my child," or better "*O pai Dios*" = "O son of Zeus," whence his identification as Zeus Ammon and the wearing of the ram's horns, which were a feature of the god in Egypt. After his pursuit of the Scythians, Plutarch is somewhat skeptical about his meeting with Amazons, and this is rather in the biographer's favour. He knows of him erecting altars to the gods once he was stopped from crossing the Ganges in India, "still revered by the local kings who offer sacrifices on them in the Greek manner." The reality of such structures left by Alexander at the farthermost point of his campaign remains a subject for discussion by scholars. The gymnosophists, Brahmin sages, gave him a lot of trouble with their smart answers. He dismissed them, however, and the episode is possibly not historical, or if anything like it did happen, it may have been with one of his followers,[7] and was to form an episode in several of the Romances. On the whole, however, Plutarch reveals little of the origins of the "real" fantasies about Alexander.

Plutarch returned to Alexander in two essays, like orations, entitled *On the Fortune or Virtue of Alexander* (*Moralia* 326–345), after a similar one *On the Fortune of the Romans*. "Fortune" is the Greek goddess Tyche, and so is rather more than our "Good Luck" since it may be judged to be deserved or earned. Alexander's "luck" seems more a matter

[7] Cf. R. Stoneman "Naked Philosophers: The Brahmans in the Alexander Historians and the Alexander Romance," in *JHS* 115 (1995): 99–114.

of good judgment and education: "yet are we to contemn anyone who asserts that the works of Homer accompanied him as a consolation after toil and as a pastime for sweet hours of leisure, but that his true equipment was philosophic teaching, and Treatises on Fearlessness and Courage, and Self-Restraint also, and Greatness of Soul?" (*Moralia* 327f–328a). Fortune too provided him with an appearance and physique in which we can see his greatness, as portrayed by artists (*Moralia* 335e–f).

From his *de Tranquillitate* 3 is the anecdote about Anacharsus, who went with him to India, telling him about the many other worlds that existed, so that "Alexander wept that there were no more worlds to conquer," which became a misleading saying of his, when he meant that he wept that he had so far yet to conquer one. "Alexander wept," unlike "Jesus wept," became a much misused anecdote.

ARRIAN

The historian Arrian offers quite a contrast. He was the Greek governor of Bithynia (in Asia Minor) at the turn of the first and second centuries AD, under the Romans, and notably favoured by the philhellene Roman Emperor Hadrian. He had travelled too and wrote up his visit to India (*Indica*). His research into Alexander's campaigns (the *Anabasis of Alexander*) was thorough. Not surprisingly, therefore, he is not too easily led into speculative fantasies, and this sadly makes him less useful for present purposes of collecting historical gossip.[8] He is properly critical of his

[8] His *History of Alexander* and *Indica* are well translated by P. A. Brunt (Loeb, 1976, 1983) with some excellent essays added as Appendices, notably, for our interests, Appendices XX and XXI, on Alexander meeting the

sources and plausibly detailed when it comes to describing localities and the conduct of battles. At Troy he says that Alexander dedicated his armor, and took some of the other, heroic armor that had been left there by heroes at the Siege of Troy, to be carried before him into battle—far more plausible than his acquisition of the very Shield of Achilles, which was an invention of Homer's at best.[9] He notes that after the Granicus battle Alexander buried the Persian commanders and their mercenary Greeks, but sent captured Greeks off in chains, and that the dedications he sent to Athens were from himself and the Greeks (except the Spartans; I.16.6–7). All this rings true, as does his account of the Gordion knot (the intricate fastening on a heroic chariot)—either Alexander cut it, or just cunningly removed the pin holding it together (II.3.7). He gives a good account of Alexander's compassionate treatment of Darius' mother, wife and children, with the comment—"I have written this down without asserting its truth or total incredibility. If it really happened I approve of Alexander's compassion.... If the historians of Alexander think it plausible ... I approve of Alexander on that ground too" (II.12.8). Alexander burnt Persepolis. "He said that he wished to punish the Persians for sacking Athens and burning the temples when they invaded Greece, and to exact retribution for all the other injuries they had done the Greeks. I do not think that he showed

Indian Sophists and the Amazons. A good account of Arrian's interpretation of Alexander in A. B. Bosworth, *From Arrian to Alexander* (Oxford University Press, 1988).
[9] W. H. Auden has a splendid poem, "The Shield of Achilles," about Thetis' dismay at what Hephaistos had wrought. On Alexander and Achilles see also E. Carney, "Artifice and Alexander History," in Bosworth/Baynham, 275–277.

good sense in this action, nor that he could punish the Persians of a distant past" (III.18.12). This seems very fair. We learn a lot too about Arrian himself in considering his comments on Alexander

Arrian had little time for Alexander's adversary, the Persian king Darius. After he was killed by his own men (led by Bessus), Arrian commented that "no man showed less spirit or sense in warfare; but in other matters he committed no offence . . . his life was one series of disasters" (III.21.2–3). When Alexander caught Bessus he had him mutilated and executed: "I do not approve of this excessive punishment" and Arrian deplores Alexander's failure to command his passions (IV.7.4–5). And after killing the drunken Cleitus Alexander is commended for admitting his error, but Arrian blames both the king and Callisthenes for their quarrel over the king's adoption of some eastern practices (IV.12.6–7). When it comes to discussing divine interventions and especially the experience of Dionysos/Bacchus in the east "one must not be a precise critic of ancient legends that concern the divine. For things which are incredible, if you consider them on the basis of probability, appear not wholly incredible, when one adds the divine element to the story" (V.1.2)—which seems a reasonable attitude for a Greek who believed in his gods; "these tales anyone may believe in or not, taking them as he thinks fit," and he takes an open view of the identification in the east of the site of Hercules' rescue of Prometheus (V.3.1–4).

To Arrian his ambitions seemed endless, from Britain to Spain; "none of Alexander's plans were small and petty . . . he would always have searched beyond for something unknown" (VII.1.1–4). He also tells the story of the Indian

sophists who faced Alexander and simply stamped their
feet to show that "each man possesses no more of this earth
than the patch he stands on; very soon you too will die, and
will possess no more of the earth than suffices for the burial
of your body" '(VII.1.5–6). It chimes well also with Arrian's
attitude to the man that recounts it, "believe it or not," and
recalls Diogenes' telling Alexander to "get out of the light."
Alexander's encouragement of weddings between Macedo-
nians and Asians is also commended (VII.4.4–8) although
he was deemed ruthless with recalcitrant Macedonians. Ar-
rian will not believe that Amazons survived to Alexander's
time or even existed at all (VII.13.2–5), but knows of Semir-
amis and agrees that "it had been accepted in Asia that
women should actually rule men" (I.23.7). He is skeptical of
any Roman embassy to Alexander (VII.155–156). He re-
counts the many stories about the great man's death "which
I have set down to show that I know they are told rather
than because they are credible enough to recount"
(VII.27.3). His admiration for Alexander and what he
achieved is nonetheless total (VII.27–30), and one is bound
to acknowledge his serious attempt to record the truth. In
Greek Romance, Semiramis can come to anticipate Alexan-
der's own eastern conquests including Asia, Egypt, Ethio-
pia, and India.[10]

[10] On Semiramis, see S. Dalley, "Semiramis in History and Legend: A Case
Study in Interpretation of an Assyrian Historical Tradition, with Observa-
tions on Archetypes in Ancient Historiography, on Euhemerism before
Euhemerus, and on the So-Called Greek Ethnographie Style," in *Cultural
Borrowings* (ed., E. S. Gruen, Stuttgart: F.Steiner, 2005), 11–22. In antiquity
Ethiopia was often confused with India.

II

His Body and Burial

Now we come to what was alleged about the man himself in various periods, the earliest sources not necessarily being the most reliable or plausible. The early accounts of Alexander's death essentially imply that it was the result of overmuch drinking, or drinking tainted wine, and probably an ensuing stroke, at Babylon. He was fond of his wine, and his cup was said to have been as large as the heroic cup of Homer's Nestor. But this is too easy, and there were several ancient sources that suggested that he had been poisoned, as well as much modern speculation about by whom and how, and whether his illness could have been the result of malaria or typhoid fever. If he was poisoned, it was likely to have been as a victim of his own family's intrigues.[1] The

[1] Particularly entertaining is the study of the story of his death from a poison acquired from the River Styx: A. Mayor, "The Deadly Styx River," Princeton/Stanford Research Paper, Sept. 2010, and in *History of Toxicology* (ed. P. Wexler, Amsterdam: Academic Press, 2014), ch.6. Many essays have been devoted to the question: B. Bosworth, "The Death of Alexander the Great: Rumour and Propaganda," *Classical Quarterly* 21 (1971): 112–136; D. Engels, "A Note on Alexander's Death," *Classical Philology* 73 (1978): 224–228; F. P. Retief, "The Death of Alexander the Great," *Acta Theologica* 26.2 (2006): 14–28; Chugg, *Quest*, 25–31. There was a tradition that a Poison Maid came from India: V. Elwin, *Myths of Middle India* (Oxford India, 1991), 363. Another recent study of his death and what happened next is J. Romm, *Ghost on the Throne* (New York: Vintage, 2012), carefully

latest medical opinions insist that it was typhoid fever, from rancid water.[2] Many stories are told about his dying remarks and wishes—for instance, for the most fanciful, that his doctors alone should carry his body because no doctor can cure everyone, that the path to his grave be strewn with jewels because he will leave nothing when he dies, that both his hands hang outside his coffin to show that he leaves the world as he entered it—empty-handed.

What happened to his body ranges in story-telling from the plausible if grandiose, to fine imaginative fiction. It inevitably involves the great city of Alexandria, which he founded, and is repeatedly reflected upon in the Romances, quite apart from the problems of his first burial.[3] He had been in Egypt for only five or six months in 332/331 BC, in which time he travelled far into the western desert to the Siwa Oasis to visit Zeus Ammon whom he regarded as his father.[4] The oracle of Zeus Ammon in Egypt had become as much respected by the Greeks as those of Zeus at Dodona and Olympia in Greece. Alexander may really have intended Egypt for his final resting place, but tradition soon found alternatives. These have been the subject for more than one scholarly monograph in recent years: Nicolas Saunders (*Alexander's Tomb, the Two Thousand Year Obsession to Find the Lost Conqueror*) and Andrew Michael Chugg (*Quest*) offer

researched especially for the reliable aspects of the military history of the period after Alexander's death. On historical problems about his death, A. B. Bosworth, *From Arrian to Alexander* (Oxford: Oxford University Press, 1988), ch.7.
[2] David W. Oldach and Robert E. Richard, "A Mysterious Death," *New England Journal of Medicine*, June 11, 1998.
[3] Stoneman, *Life* 53–66, and on his death, ch. 10.
[4] M.-F. Boussac, "Creating Alexander's Legacy in Egypt," in *Memory*, ch. 14.

valuable commentaries, and there are many essays by others. The story of his death and the immediate sequel excited the curiosity and imagination of authors almost immediately. The essence of the surviving *Liber de Morte* has been thought to go back to Ptolemy himself and before the end of the fourth century BC, dealing with Ptolemy's activities with Alexander's body and the will.[5] Ptolemy is certainly a key figure in the story of Alexander in the years immediately after his death. It is interesting that, historically for a change, he chose an Indian setting for his own issue of a gold coin showing the great man, in a chariot with four elephants and holding a cornucopia, thunderbolt and *aegis* (attributes of Zeus), a nice mixture of plausible history and legend.[6]

At one point Alexander was said to have expressed the wish to be buried in the River Euphrates, but he deserved better. And for a monument it had been suggested to him that Mount Athos in north Greece could be reshaped to represent him, a project that he rejected but that has stimulated some drawn reconstructions of its appearance, if it had ever happened (fig. 2). Athos was traditionally a staging point on the way to Olympus, the home of the gods and was to become the site of many Christian monasteries. The obvious last resting places must have been either his home in Macedonia, where a great memorial was in fact to be erected, or in Egypt at the sanctuary of Zeus Ammon at Siwa, since he was deemed a mortal expression of the god (whence the rams' horns he often wears), and some said that this was the his own choice. Arrhidaeus took control of the body. It was

[5] B. Bosworth, "Ptolemy and the Will of Alexander," in Bosworth/Baynham, ch. 7.
[6] Stoneman et al. 2012, 389, fig. 4.

25

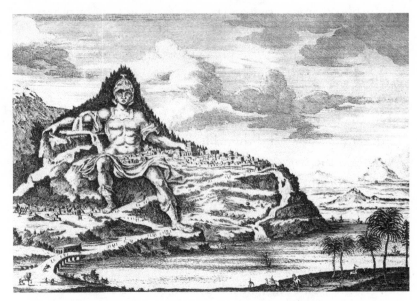

FIGURE 2. Alexander as a sculptured Mount Athos, north Greece. Eighteenth-century reconstruction by Fritz von Erlach.

embalmed, dressed in armor and coated with gold leaf, which revealed his features clearly, placed in a gold sarcophagus filled with honey as a preservative, and covered with "hammered gold." For the journey an Ionic temple-like structure was built, with figures of Victories, bells, golden nets, panels showing the king, his retinue and fleet, and two golden lions facing forward over the sixty-four mules that pulled it. Various reconstructions have been attempted (fig. 3). The body started its travels some two years after his death.

Perdiccas had taken control of the body and set out with it, but the procession was hijacked by Ptolemy in Syria. He took the body to Memphis, which was then Egypt's capital city. Perdiccas tried to regain it by attacking Egypt. In Memphis it seems likely that the body was installed in the great

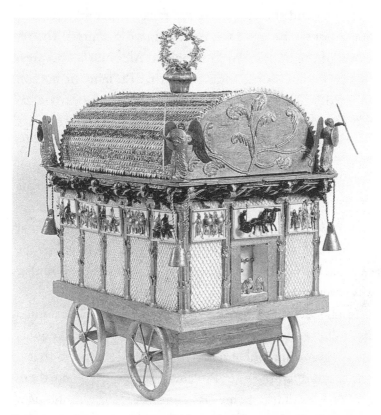

FIGURE 3. Reconstruction of Alexander's hearse by Stella Miller-Collett. © Stella Miller-Collett.

Serapeum sanctuary, in the desert to the west. If so, visitors would have been greeted by a great array of life-size statues of Greek philosophers. So in Memphis he was, for the first time, buried, yet still proves as elusive after his death as he was so often in his life. And there were always claims for his body in a more Egyptian ambience, such as the Temple of Amenhotep, far to the south at Luxor, which he had rededicated.

The nature of his tomb and monument in Alexandria—known as the Sema (Memorial) or Soma (Body)—is

unknown and therefore a source for considerable specula-
tion among scholars. Even its location is disputed. The re-
moval of the body from Memphis to Alexandria also pres-
ents problems. Some sources say that Ptolemy or his son
effected it. This seems highly probable. In the early 270s
BC, the son, Ptolemy Philadelphus II staged a magnificent
procession in Alexandria, which was highly Dionysiac in its
themes and included colossal statues of Alexander and of
personifications of Greek cities, with finally a golden statue
of Alexander on a carriage drawn by four elephants, and fig-
ures of Victory and Athena.[7] One cannot help but feel that
by then the great man's body was already installed in the
city that he had founded and where the Cult of the Founder
was practiced.[8]

Strabo seems to suggest that the first burial in Alexandria
was followed by a second, designed by Ptolemy at Vergina,
once a grand mausoleum had been built for it; also that it
was surrounded by other Ptolemaic tombs, in the northern
part of Alexandria. Some clay lamps showing a monument
with a pyramidal roof have been thought to show its exte-
rior, but we know remarkably little about its appearance. It
had many notable visitors, not least Roman leaders, includ-
ing some of the emperors.[9] These included Julius Caesar, Oc-
tavian (yet to become the emperor Augustus), while Cleopa-
tra was alleged to have stolen gold from the tomb, and there

[7] See J. Boardman, *The Triumph of Dionysos* (Oxford: Archaeopress, 2014),
ch. II for the procession; and P. M. Fraser, *Alexandria* (Oxford: Oxford
University Press, 1972), I 202–203. Saunders, *Tomb*, ch. 4.

[8] See also Fraser, *Alexandria*, I 16–17; II 21–22, 31–33, 36–42. Saunders,
Tomb, 174, for scorn of the reconstructions offered.

[9] Saunders, *Tomb*, chs. 5, 6. In the third/fourth century AD Julius Valerius
kept the story alive by a translation into Latin of Pseudo-Callisthenes.

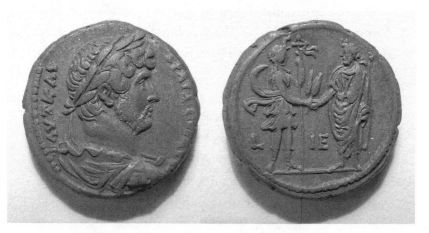

Figure 4. Coin showing the Roman Emperor Hadrian greeting Alexander. Image courtesy of Andrew Michael Chugg: www.alexanderstomb.com. © A. M. Chugg.

was the possibility that the golden sarcophagus was replaced by one of glass. The Grecophil Roman Emperor Hadrian was particularly anxious to at least appear as a new Alexander, and had coins struck showing Alexander greeting him (fig. 4). Emperor Severus arrived to see him in AD 199 and was concerned over the condition of the tomb. He resealed the tomb and buried magic books in it. Next came Emperor Caracalla who detected a likeness to himself in the corpse and tried to imitate Alexander's adventures. But Emperor Diocletian came and sacked the city in AD 298, and the fate of the tomb again becomes a subject for speculation and invention. "By 298 Alexander's tomb had entered the realm of rumour and legend, half-truths, possible sightings, romance and deception" (Saunders, *Tomb* 93).[10]

[10] On the search for the tomb see footnotes 11–18 and Hellenic Electronic Center, www.greece.org/alexandria/tomb2/church.htm (H. E. Tzalas).

With Christianity flourishing in the east in the new Rome at Constantinople (Byzantium), interest in Alexander could revive. Julian the Apostate came to the throne in AD 361, deemed himself a reincarnation of Alexander and was ready to re-create his empire. Alexandria suffered a great earthquake in AD 365, which could hardly have done other than further damage its monuments. Later in the century Libanius sought to preserve Alexander's body, but it is a moot point whether in fact anything of the ancient tomb remained, except in the imagination of those who valued Alexander's memory. In AD 391 Emperor Theodosius damned paganism in the empire, and in about AD 400 Bishop John Chrysostom condemned pagan Alexander's memory in no uncertain terms, but he had reason to be worried since there was some sign of Alexander being associated with Christian behaviour, and his image could be associated with the name of Christ.[11]

In the Muslim world Alexander was the "two-horned master," Zulqarnein, and even the construction of mosques could be attributed to him, while there were alleged visits to his tomb. Muslim scholars were more inquisitive than many others in that period, as we shall see when we come to the Romances. In the ninth century Caliph Al Mamun was one of many who explored Alexandria—Cairo too, where he found a hidden chamber in the Great Pyramid. He never claimed it for Alexander, though a modern writer has.[12] The seventeenth-century English poet George Sandys visited Alexandria and was told that Alexander's remains were in a

[11] Saunders, *Tomb*, 109, 119.
[12] Lucy Caxton Brown, *Alexander* (London: New Generation, 2014).

sarcophagus in the Attarine mosque, built in the ruins of St. Athanasius' church—the sarcophagus was that of the fourth-century BC Pharaoh Nectanebo, Alexander's near contemporary. In the late sixteenth century, a map had already marked a Domus Alexandri Magni and by the late nineteenth century others had already crept in to view him in the Nabi Daniel mosque.[13]

For Napoleon Alexander was a hero to be emulated for his conquests, but his own attempts to strike at the east from Acre and extend his empire were abortive. In the late eighteenth century, Napoleon was in Egypt, and despite his defeat by Nelson, he established an academic team to explore and record Egypt's past; this included Dominique Denon. However, Napoleon plays a part in the story since Denon found the Nectanebo sarcophagus and took it to Cairo, where he also found the Rosetta Stone, with its long multilingual inscriptions, which were to help decipher Egyptian hieroglyphic writing—a challenge soon to be met by the French scholar Champollion. Then an English savant, Edward Daniel Clarke, comes upon the scene and is told of the green stone sarcophagus (fig. 5) which had been taken by the French, as Alexander's. Both the Rosetta Stone and the sarcophagus were removed and brought to the British Museum, where they are now (at least in 2018) displayed in the museum's main Egyptian gallery. The sarcophagus' hieroglyphic inscriptions showed it to belong indeed to the fourth century BC, but to the Egyptian pharaoh Nectanebo II, who plays an important part in Alexander legend and in the Romances, where he often figures as the father of

[13] Saunders, *Tomb*, 125–128.

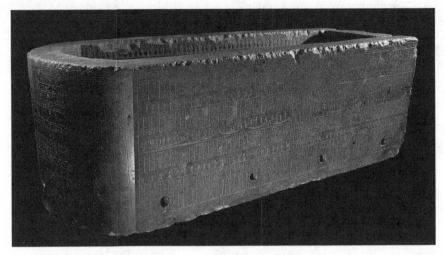

Figure 5. The sarcophagus of Nectanebo II. British Museum, London. ©Trustees of the British Museum.

Alexander. The sarcophagus carries the cartouche of Nectanebo and a long funerary text—but no mention of Alexander.[14] The scholar Andrew Michael Chugg, however, believes that it had in fact been re-used for Alexander and much visited. We might also notice that Chugg has also now suggested that, when the Venetians came to dig up the mummified body of St. Mark, what they took was Alexander's, which is now therefore in Venice.[15]

In the nineteenth century, the city of Alexandria was further explored by scholars, producing nothing certain, although the search involved names such as Schliemann and Mariette. In the mid- and later nineteenth century, Mahmoud Ali Bey made a careful map of Alexandria, which proved inconclusive, and Schliemann, of Troy fame, wanted

[14] Ibid., ch.9.
[15] Answered, ibid., 198–199.

to dig but was not given permission.[16] In the twentieth century came Howard Carter, who discovered Tutankhamun's tomb. The distinguished excavator of Mycenae, Alan Wace, was a professor in Alexandria at the end of the Second World War and supported the Nectanebo connection, but thought that the sarcophagus had been deposited in the Memphis Serapeum.[17] An alabaster gate-like structure was found there in 1907 in the Roman cemetery area and was restored in 1936 by Adriani, who thought it might be the ante-chamber to Alexander's tomb.[18] Alexandria's cemetery area is better known by now, but with no safe haven for Alexander, and an alleged tomb for him at the Siwa shrine has proved equally impossible. But we may be sure that the search, in theory or practice, however hopeless, will not be abandoned. The scholar-archaeologist Jean-Yves Empereur, who has long lived and worked in Alexandria, suspects that the tomb was destroyed during the wars of the second half of the third century AD. But, inevitably somehow, hope always lingers, and he writes, "Was the tomb really within the heart of the Palace Quarter, or at its edge? It is not inconceivable that archaeologists may one day happen on Alexander's tomb—but if they did, would they necessarily recognise it, given its likely state of dilapidation?"[19]

[16] Ibid. ch. 10.
[17] Answered by Chugg, *Quest*, 256–257.
[18] Saunders, *Tomb*, ch. 11. J.-Y. Empereur, *Alexandria: Past, Present and Future* (New Horizons, Thames and Hudson, 2002), 18.
[19] Ibid., 18–19. A good account of the city appears in P. Goukowsky, *Alexandrie, lieux de culte et de mémoire* (Nancy: De Boccard, 2014). The Alexandrian Greek poet Cavafy sometimes reflects on Alexander; see, for his attitudes to antiquity, G. W. Bowersock, *From Gibbon to Auden* (Oxford: Oxford University Press, 2009), 162–165.

Elsewhere, at Siwa Oasis, the site of "father" Ammon's temple, the Greek archaeologist Souvaltsi claimed in 1989 to have found the tomb and supported his claim by some quite fanciful reconstructions of buildings, skeletons, and inscriptions.

Other "sightings" have been recorded—from early times. A Greek monk Sisoes, of the ninth century AD, lived in Egypt as a hermit. There is no early record of his experiences, but from the fifteenth century on, when Greece became part of the Muslim, Ottoman empire, there are numerous pictures in Greek churches of Sisoes grieving over an open sarcophagus containing Alexander's body (fig. 6).[20] This may have been inspired by a Romance, but . . . imagination can readily supply what the spade cannot. It would be nice to think that, in his day, Sisoes did indeed gaze on Alexander.

A different sort of memorial for him was a temple founded by him or in his honour. He was alleged to have wished to rebuild the Temple of Artemis at Ephesus, which was said to have burned down on the day he was born, but he did not. He might well have been regarded as a god, but actual recognised images and structures are few and far between (for the images see the next chapter). At the great Ammon (Amun) temple of Luxor in Egypt there is a granite ship shrine in which he is represented, in Egyptian guise, facing Amun, in a temple relief (fig. 7). One might wonder whether the ship connection was important, since in later

[20] C. J. Durand, "Légende d'Alexandre le Grand" in *Annales archeologiques* 25 (1865): 155–156. Many icons on Mt. Athos and in Novgorod Cathedral. There is a painting of Alexander beside Augustus in a Mt. Athos monastery of 1568.

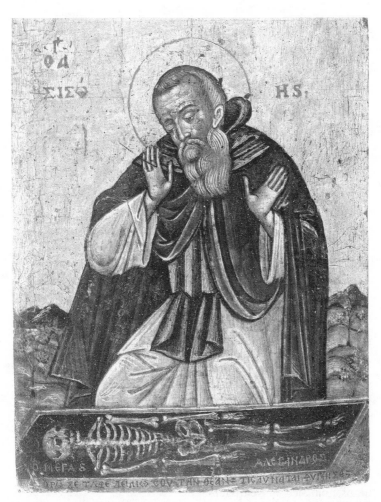

Figure 6. Wall painting. Sisoes grieves over Alexander's body. Painting from Mt. Athos monastery. Hermitage Museum, St Petersburg. Photograph © The State Hermitage Museum / Photo by Vladimir Terebenin, Leonar Kheifets, Yuri Molodkovets.

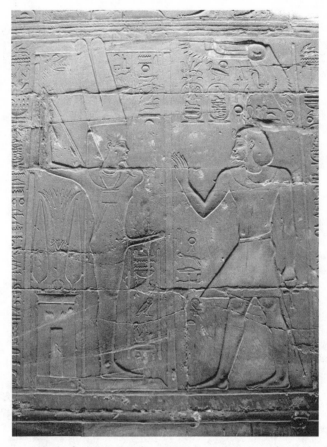

FIGURE 7. Relief at Temple of Luxor, Egypt, showing Alexander facing the Egyptian god Amun. Fourth century BC. WikiMedia Commons, uploaded by Neithsabes.

times Alexander is much associated with the Dionysus-triumph reliefs, which figure a ship being carried, itself an image borrowed from Amun worship in Egypt. [21]

[21] Cf. J. Boardman, *The Triumph of Dionysos* (Oxford: Archaeopress, 2014), chs. 1–3. An example of Dionysiac behaviour for Alexander in a Romance—Stoneman et al. 2012, 99f.

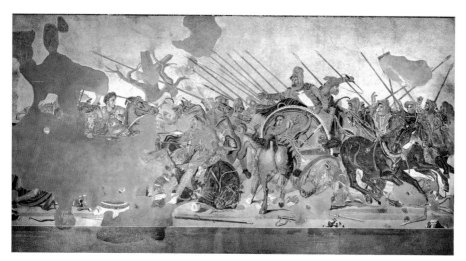

PLATE 1. The Alexander Mosaic from Herculaneum. Alexander defeating Darius. Mosaic floor from Pompeii copying a Greek fourth-century painting. Height 2.71m. Naples Museum. AKG-images / Album / Prisma.

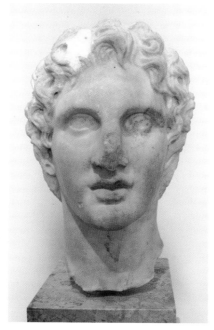

PLATE 2. Head of Alexander from the Acropolis. Late fourth century BC. Acropolis Museum, Athens. Acr. 1331.

PLATE 3. Cornelian intaglio with Alexander holding Zeus' thunderbolt. Signed by Neisos. third century BC. Height 3 cm. Hermitage Museum, St Petersburg. Photograph © The State Hermitage Museum / Photo by Vladimir Terebenin, Leonar Kheifets, Yuri Molodkovets.

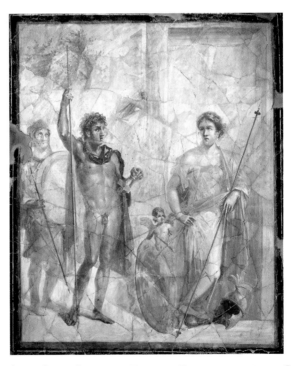

PLATE 4. Alexander and Roxane. Fresco in Pompeii copying a Greek painting. About 275 BC. De Agostini Picture Library / A. Dagli Orti / Bridgeman Images.

PLATE 5. Alexander in his Flying Machine lifted by two griffins reaching for the meat held over them. Twelfth century AD. Painting in Otranto Cathedral. AKG-images / Erich Lessing.

PLATE 6. "The Alfred Jewel"—a gold and glass pointer signifying Sight. Alexander holding out branches. Ashmolean Museum of Art and Archaeology, University of Oxford.

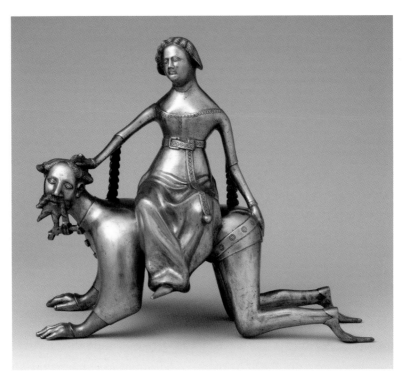

PLATE 7. Copper alloy acquamanile (for washing hands at table). Phyllis rides Aristotle. The Metropolitan Museum of Art, New York. Robert Lehman Collection, 1975.

PLATE 8. Alexander in his diving bell. Parchment, Regensburg, about 1400. Getty Museum, Malibu. Digital image courtesy of the Getty's Open Content Program.

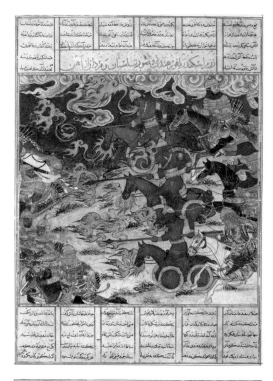

PLATE 9. Persian painting. Iskandar's Iron Cavalry Battles King Fur of Hind, illustrated folio from the Great Ilkhanid Shahnama (Book of Kings), c. 1330–1340. Harvard Art Museums / Arthur M. Sackler Museum, Gift of Edward W. Forbes. Image © President and Fellows of Harvard College.

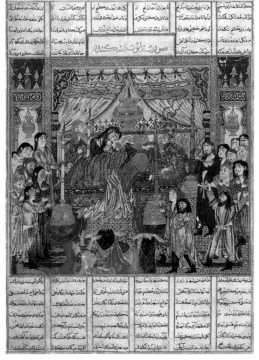

PLATE 10. Persian painting. The bier of Iskandar. Tabriz, AD 1330–1336. Freer Gallery, Smithsonian, Washington, DC.

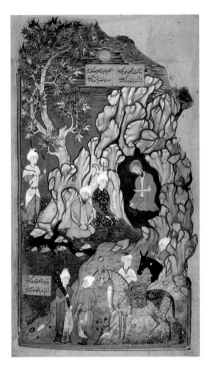

PLATE 11. Persian painting. Alexander visits a hermit. Mid-sixteenth century AD. British Museum, London. © British Library Board. All Rights Reserved / Bridgeman Images.

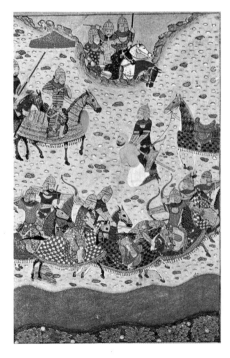

PLATE 12. Persian painting. Darius captured by Alexander. AD 1410. Gulbenkian Library, Lisbon.

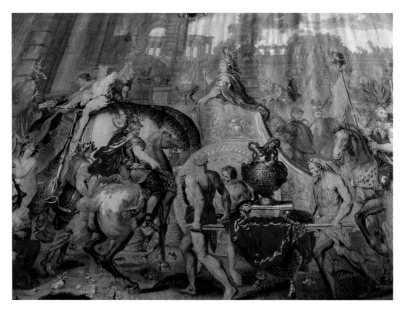

PLATE 13. Tapestry: Alexander enters Babylon. Blenheim Palace, Woodstock. Photo, Julia Boardman.

PLATE 14. Tapestry: Alexander greets Hephaistion. Blenheim Palace, Woodstock. Photo, Julia Boardman.

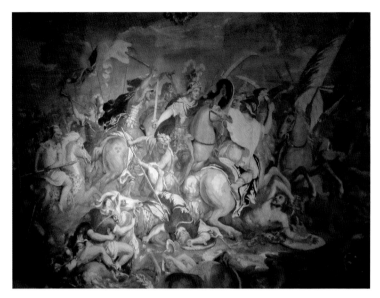

PLATE 15. Tapestry: Battle of Granicus. Blenheim Palace, Woodstock.
Photo, Julia Boardman.

PLATE 16. Tapestry: Alexander
meets the wild men. Blenheim
Palace, Woodstock. Photo, Julia
Boardman.

Siwa, where he met the god Ammon, might seem a likely burial place, and an American archaeologist claimed to have found it in what is in fact a first-century AD Doric temple.[22] On his way back from Siwa in Egypt, Alexander had probably visited the Bahariya Oasis (some 380 km west of the Pyramids) in the western desert. There a temple for him—a two-roomed structure of Egyptian type—has been excavated, most recently by the indefatigable Chief of Antiquities, Dr. Hawass. It has not been properly published, but the reports include mention of Alexander's name on an altar (a cartouche?) and a relief showing him (?) making an offering to an Egyptian god.[23] General Papazois of the Greek army still thinks he was buried in the great tomb at Vergina in Macedonia, and this aroused no little modern patriotic fervor, but the Vergina tomb is much later.[24] Alexander has again become a "political football."

He had less of a record in the Catholic Roman world (apart from the Venice story, just mentioned, and some wall illustrations), but one source alleges that Pope Paul III had the bones of Alexander and St. Paul in the Castel San Angelo, with a vault depicting Alexander kneeling before the High Priest, and the legend *Omnes Reges servient Ei* (all kings serve Him).[25]

[22] Saunders, *Tomb*, 179–183.

[23] Ibid., ch. 14.

[24] Ibid., 187–189.

[25] The report of a tomb of "Alexander the Great" at Broome in Western Australia, the result of Alexander's further travels east, needs confirmation. Also in Western Australia, at Wundowie, near Perth, there is an "Alexander the Great Mansion," a massive building with a copy of the usual statue of the man on horseback in front.

III

The Alexander Portraits
in Antiquity

Unlike the Greeks, the Macedonian nobles shaved, and so did Alexander, giving him, as it were, a head start in the problems of portrait identity in a period when most Greeks' portraits were bearded. His reason for shaving was probably to continue giving an image of youthful achievement, rather than to deny a grip to any hand-to-hand enemy, which was what Plutarch thought (*Thes.* 5).[1] Some portraits give him an *anastole*, a "quiff" of hair over the forehead. On the Alexander Mosaic from Herculaneum he was given a short line-of-chin beard (plate 1).

His life and experiences, real and imagined, were always ready subjects for illustration, and as time passed conventions for showing him and his deeds developed from the probably real, of his lifetime, to the imaginary but based on exaggeration of the "real," to the totally fanciful. Lifelike portraiture had appeared first in Greek art in the later part of the fifth century BC—possibly first among the Greeks of Asia Minor, to judge from coinage. Since the Greeks were

[1] Alonso Troncoso in *Philip II and Alexander the Great* (eds. E.D. Carney, D. Ogden, Oxford: Oxford University Press, 2010), 13–24.

not a people who had "kings," the portraits are of philoso-phers, politicians, and the like, but in an Asia Minor ruled by Persians the idea of a royal or ruler portrait was more acceptable, and might be used on coins of Greek type being made for Persian governors (satraps).[2] Alexander was royal, non-Greek, and so a safe subject. Andrew Stewart lists no fewer than 48 ancient references to Alexander's appearance and 109 to Hellenistic (which means "after Alexander") and Roman Republican portraits of him (Stewart, *Faces,* Appen-dices 1, 2). Among the good Hellenistic portraits are the marble head (plate 2) from the Athens Acropolis. His coin portraits—contemporary, later, and non-Greek—have often been studied (fig. 8).[3] The wild hair and jutting fea-tures are characteristic, and for dress some variety—a lion (skin or head, as Hercules), an elephant's head, a skin hel-met, the real Macedonian *kausia* (flat cap).[4] "Normally" he wears Macedonian armor, based on Greek, but with some

[2] Cf. J. Boardman, *Persia and the West* (London: Thames & Hudson, 2000), 174–178.

[3] There are many studies of Alexander coin portraits. See M. J. Olbrycht, "O portretach monetarnych Aleksandra Wielkiego," in *Zapirki Numizm-tyczene* 6 (2011): 11–26, reviewing F. Smith, *L'immagine di Alessandro il Grande sulle monete del regno (336–323)* (Milan: Ennere, 2000); O. Bopearachchi and P. Flandrin, *Le Portrait d'Alexandre le Grand* (Monaco: Rocher, 2005). For medallions related to Alexander and his history, see D. Pandermalis, *Alexander the Great, Treasures* (New York: Onassis Fdn., 2004), nos. 9–14.

[4] A good brief study of the influence of his portrait is O. Palagia, "The Im-pact of Alexander the Great on the Arts of Greece," *BABESCH 9th Byvanck Lecture* (Leuven: Peeters, 2015); and see Palagia, "The Impact of Alexander the Great in the Art of Central Asia," in Stoneman et al. 2012, 369–382 (on his portrait in the east), and A. Fulinska, "Oriental Imagery and Alexan-der's Legend in Art: Reconnaissance," ibid., 383–404.

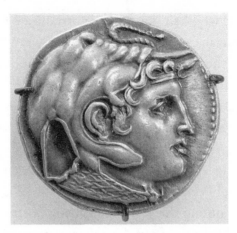

FIGURE 8. Silver tetradrachm of Ptolemy I showing Alexander wearing an elephant headdress. About 315–305 BC. © Marie-Lan Nguyen / Wikimedia Commons.

variety in helmet shapes, and in mufti he looks more or less Greek. Later he wears the Macedonian diadem, a simple ribbon.[5] He was perhaps slightly stocky rather than short, though it was said that he needed help dismounting and a taller than usual footstool.[6] His wild eyes become a recurrent feature of portraits and a Romance attribute—*heterochromia* to him—one eye light/one eye dark.

For early portraiture, Macedonia has yielded a number of paintings of Greek style from the fourth century, and some see a portrait of the young Alexander in an ivory head (fig. 9) found in the Vergina Tomb (II), which used to be ascribed to Philip II, his father, but is later. Plutarch says that

[5] L. Llewellyn-Jones, *King and Court in Ancient Persia, 559 to 331 BCE* (Edinburgh University Press, 2013), 61.
[6] Thus, Deinon and Curtius, ibid., 169.

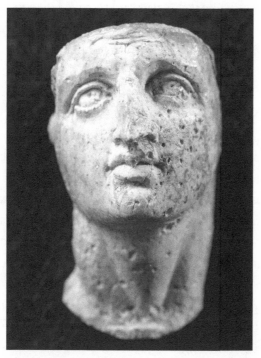

FIGURE 9. Ivory head from Vergina, attached to funerary couch. Possibly a portrait of Alexander. De Agostini Picture Library / G. Dagli Orti / Bridgeman Images.

Lysippus, the famous Greek sculptor, made statues of him, which the sitter judged accurate—including the "poise of his neck, bent slightly to the left, and his melting expression." He was said to have sat often for the Greek artist Apelles, whose style was certainly realistic but who, Plutarch says (Plut., *Alex.* 4), made his complexion too swarthy. Pliny (*NH* 35, 86–87), writing in the first century AD, says that Alexander forbade anyone other than Apelles to make a portrait of him. But even this prosaic art of portrait-making

created an anecdote. He was said to have fallen in love with the artist's girlfriend Pancaspe (later known as Campaspe). He commissioned a nude painting of her but conquered his feelings and left her to the painter. Apelles also painted him holding Zeus' thunderbolt (*NH* 35, 92) for the Artemis Temple at Ephesus, in four colours, which had the effect of making his fingers appear in relief. A nakedly divine Alexander, holding Zeus' spear and thunderbolt, beside his eagle and a shield, was carved on a cornelian gemstone by the artist Neisos, in the late fourth century (plate 3).[7] Certainly, by the Roman period, a portrait type had been established showing him with unruly hair and a bold forehead. Other early paintings by Apelles of Alexander were placed by Augustus in his Forum. The Emperor Claudius cut out Alexander's head from them and substituted that of Augustus (*NH* 35, 94), but the desire to be assimilated to Alexander was already well under way.

When Pompey "the Great" (a suffix like Alexander's, a posthumous Roman invention) celebrated his victories in the east in 61 BC, he mounted a parade triumph modelled on those used to celebrate Alexander, notably the great festival in Alexandria in the 270s. He wore what was taken to be Alexander's cloak,[8] and imitated his hairstyle. The man was on everyone's mind. Even when the politician Cicero had to serve as a soldier in Cilicia and won a minor victory, he was conscious that he was in the footsteps of Alexander "who was a better general than you or I" (he wrote to his

[7] Stewart, *Faces* figs. 66–67.
[8] J. Boardman, *The Triumph of Dionysos* (Oxford: Archaeopress, 2014), 26–27. The ownership of the cloak traced: A. Mayor, *The Poison King* (Princeton, NJ: Princeton University Press, 2010), 38–39.

friend Atticus). But later Romans reckoned that their empire would have beaten Alexander's. It is hardly surprising that Alexander should be taken by Rome as a model for the ideal conqueror to whom boundaries meant nothing. The Romans' eastern military ambitions were to prove generally fruitless, and their Alexander-like successes were to be recorded rather to the north, west, and south, and usually not against well-organised empires like the Persian, except when they faced Phoenician/Carthaginians. This did not stop them regarding Alexander as a paradigm for their military ambitions, and this is reflected in the art they collected and created.

The Romans had to depend for their arts very heavily at first on Hellenistic Greek traditions and were not slow to employ Greeks or to make copies. Rome acquired Greek "classical" art by the import of works of art, and by the employment of Greek artists. Most early signed works in the Roman world are by Greeks and signed by them, even if only slave names like Felix (but written in Greek, on a gem). Pictures of Alexander's deeds were installed in Rome before the end of the first century AD.[9] Five of those recorded by Pliny figured Alexander: in the Forum Augusti—the Castor and Pollux with Nike and Alexander, and the Alexander and Polemos, by Apelles; in the Porticus Octaviae—the Alexander, Philip and Athena by Antiphilos; in the Porticus Philippi—the Alexander as a boy by Antiphilos; and in the Porticus Pompeii, the Alexander by Nikias.

[9] J. J. Pollitt, "The Impact of Greek Art on Rome," *Trans. Amer. Phil. Assoc.* 108 (1978): 155–174. His *Art in the Hellenistic Age* (Cambridge: Cambridge University Press,, 1986) gives an excellent account, with most of the important Alexander portraits discussed.

The portrait heads have been fully studied by Andrew Stewart (*Faces*), and I make no excuse for concentrating rather on the figure- and action-studies. For these we inevitably turn first to the most famous of the Greek works copied in Italy, the mosaic found in the second-century BC House of the Faun at Pompeii (destroyed in AD 79): the "Alexander Mosaic," depicting the defeat, but not death, of King Darius at the Battle of Issus in 333 BC (plate 1). The mosaic was laid as the floor of a large alcove (*exedra*) in a prominent position for visitors, and parts of it had been restored. It is now exhibited in the Naples Museum, on a wall. The technique is unusual, and unlike the more familiar mosaic compositions of later years, in that it is made of nearly a million tiny, coloured cubes (*tesserae*), which enabled artists to come far closer to the original appearance of the figures as painted. At this early date we find mosaics composed of pebbles more often than of custom-made cubic *tesserae*. A wild-eyed Alexander storms forward on horseback, lance lowered to strike, while the distraught Darius, a little way off, flees in his chariot, a hand thrown back in a gesture of despair, acknowledging defeat. The picture has been much studied, most usefully, I think, in Stewart's book, and more recently in an article by Olga Palagia.[10] The brilliance of the artist's vision is expressed in realistically contorted figures, even mirrored—the fallen Persian below Darius is reflected in his shield. The painter of the original is unknown: Palagia suggests Helena of

[10] In *Greece, Macedonia and Persia* (eds. T. Howe et al., Oxford: Oxford University Press, 2017), 177–187.

Egypt, known to have painted the Battle of Issus with the victorious Alexander. That it was an original Roman composition is, for that date, impossible. The picture itself was exhibited by Vespasian in the Temple of Peace in Rome.[11] Palagia further suggests that for illustrating Alexander's exploits "artists adopted a visual language that had already been developed in Athens for the depiction of the Persian Wars of 490 and 480 BC, and that the image of the Persian opponent became a stereotype that was carried from the early fifth to the early third century BC."

There may have grown up a tradition of Greco-Macedonian paintings of battle of which this is an early example. One feature on it, however, leads us to consideration also of traditions in other media depicting battle: it is the throwaway gesture of Darius' right arm. This is indeed a natural one, and we see it again, often in the Greek vase painting of southern Italy (Apulia) of the years around the time of the original painting that inspired the mosaic. It is one that takes its origin probably in the arts of the Near East. A number of the scenes on the vases are of battle and it seems not improbable that they draw also on a Near-Eastern iconographic tradition—later Greco-Macedonian, perhaps—of depiction of battle and especially of scenes relating to the battles of Persians with Greeks or Macedonians. A scene on another of the South Italian vases, not of battle, gives us the only realistic representation in ancient art of the court of Darius at Persepolis.[12] What the connection was is

[11] Stewart, *Faces,* 376, p. 10.
[12] J. Boardman; *The Greeks in Asia* (London: Thames & Hudson, 2015), 49,

hard to fathom, but there was clearly some personal knowl-
edge of and interest in such matters in homeland Greek and
eastern iconography. When it comes to Darius' gesture,
there is even more, since it can be shown to have been a fea-
ture in other eastern representations of battle, and so came
to be regarded as a traditional iconographic feature as an
admission of defeat, not only in the Greek world since it
occurs even earlier on Persian work depicting Scythians flee-
ing from Persians,[13] and even earlier on a Mesopotamian
cylinder seal.

There are other Alexander images at Pompeii—paint-
ings that may or may not be copies of Greek originals but
that were certainly inspired by iconography created in the
Greek world. One in the House of the Vettii shows a seated
Zeus with thunderbolt that strongly recalls the reports of
Apelles' life portrait of Alexander.[14] There are sculptures
too, such as the bronze equestrian statue from Hercula-
neum (fig. 10).[15] There are several head types of the sec-
ond/first centuries BC too that derive from good mod-
els—from Pergamum, Pella, Cos, and the "Azara" herm in
Paris (fig. 11).[16]

Exceptionally, he appears as a baby being attended by a
nymph in a shell, his mother seated above him, a serpent
on her arm, on a fourth-century AD mosaic found in the

fig. 27; idem, "The Darius Vase" in ΑΕΙΜΝΗΣΤΟΣ (Misc. M. Cristofani,
2005), 134–139.

[13] J. Boardman, *Persia and the West* (London: Thames & Hudson, 2000),
195, fig. 5.78.

[14] Stewart, *Faces*, fig. 65.

[15] Stewart, *Faces*, fig. 21.

[16] Stewart, *Faces*, figs. 45–46.

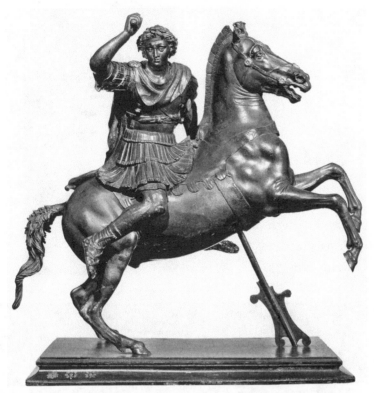

FIGURE 10. Bronze statue of Alexander on horseback, from Herculaneum. Late fourth century BC.

Villa of Souedia near Baalbek in Lebanon (fig. 12). This seems to be one of four panels (one above it showed Aristotle) devoted to Alexander and illustrating Pseudo-Callisthenes.[17] Near the Sea of Galilee another mosaic, at Huqoq in a fifth-century synagogue, may possibly represent an Alexander and elephants and perhaps his meeting with the High Priest of Jerusalem. Contorniate

[17] Ross, *Studies* 339–361, pl. 1a.

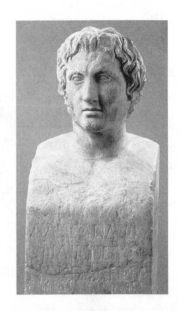

FIGURE 11. The "Azara" herm. Copy of a fourth-century BC original portrait of Alexander. Louvre, Paris.

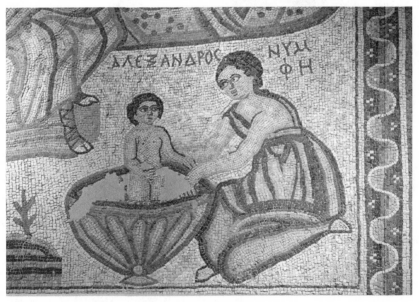

FIGURE 12. Detail of a mosaic found in Lebanon. Alexander as a baby in a basket. Photo by Egisto Sani.

medallions of the fourth/fifth centuries AD carry related scenes, as one showing Olympias reclining and fondling a snake (fig. 13), a recollection of the extreme snakiness always associated with her.[18]

It is hardly surprising that classicising works in Asia should sometimes repeat the features of Alexander, whether he was intended or not—that is, apart from plentiful coinage, where we find one of the finest Alexander heads on a gold coin, quite recently recovered (fig. 14), on which he is wearing an elephant cap, appropriately eastern.[19] Shortly before his death, it seems, he minted medallions at Babylon that proclaimed his divinity—on one side he is shown as Zeus holding the god's thunderbolt and attended by Victory; on the other as a cavalier attacking an Indian elephant (fig. 15).[20] An unusual and fine portrait appears on a gemstone of elbaite (a rare form of tourmaline), with a tiny inscription in Indian kharoshti at the neck, so locally made (fig. 16).[21] The heavy forehead and glower are easily recognised. A clay bust of him from Hadda (east of Kabul in Afghanistan) has these features.[22] And I suspect him in the

[18] Ibid., 361, pl. 6a. Contorniates are coinlike medallions with grooved edges.

[19] J. Boardman, *The Greeks in Asia* (London: Thames & Hudson, 2015), plate VII.

[20] Ibid., 57, fig.28.

[21] Boardman, *Diffusion*, 119, fig. 4.54.

[22] Boardman, *Diffusion*, 143, fig. 4.89. A coin with a similar obverse with the elephants has on the other side a very Egyptianizing quadriga with a royal archer, no doubt the Egyptian Alexander (Prabha Ray/Potts, *Memory*, 221, fig. 15.6). The attempt to identify him on a Central Asian phalera is not, I think, acceptable: it is a facing head of a satyr: J. H. Shanks, "Alexander the Great and Zeus Ammon" *AWE* 4 (2005): 150, fig. 4.

FIGURE 13. Contorniate (coin/medallion) showing Olympias fondling a snake. © Livius.org.

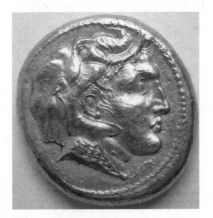

FIGURE 14. Gold coin from Afghanistan with Alexander wearing an elephant cap. © Osmund Bopearachchi.

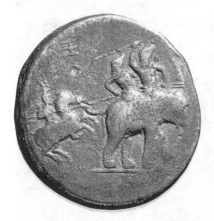

FIGURE 15. Silver coin minted in Babylon showing Alexander as Zeus, and attacking a war-elephant.

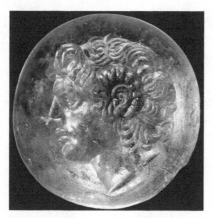

FIGURE 16. Elbaite gem with the head of Alexander and an Indian inscription. Ashmolean Museum 1892. 1499, Oxford.

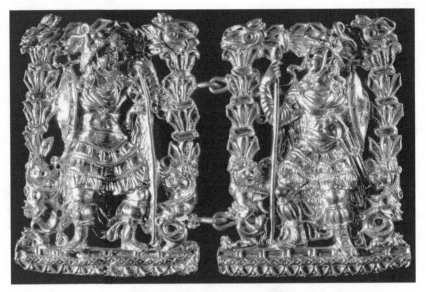

FIGURE 17. Gold plaque from Tillya Tepe, Afghanistan. Alexander? Kabul Museum, Afghanistan / Bridgeman Images.

warrior on a pair of gold plaques from Tillya Tepe, a settled/ nomad town south of the River Oxus, of the first century AD (fig. 17).[23]

[23] J. Boardman, *The Greeks in Asia* (London: Thames & Hudson, 2015), 113, pl. XXXII above.

IV

The Alexander Romances in the Middle Ages

Fantastic tales about Alexander's life and adventures after he had conquered the "known world," were current soon after his death. Very possibly these were to some degree modelled on the early epic and heroic legends in Greek literature.[1] The new stories seem to find their origin mainly in Ptolemaic Egypt, which is hardly surprising given Alexander's associations there in life and death. To give a taste of their variety, they include the famous *Liber de Morte* which includes the remarkable portent for Alexander of his death: a peasant woman bringing him in Babylon a monster to which she had just given birth—a male body with the lower parts of five wild animals, decomposing—a monster then variously interpreted for him.[2]

[1] See G. Anderson, "The *Alexander Romance* and the Pattern of Hero-Legend," in Stoneman et al. 2012, 81–101. Recent literature on the Romances is vast but Stoneman, *Life* usefully discusses most of the subjects separately, and elsewhere he and others have dealt with the national versions and their content, as I attempt to here. Stoneman, *Greek*, 7–27 gives a valuable brief account of other versions. A very full bibliography of the mediaeval sources by Emily Rebekah Hube appears at http//www.library .rochester.edu/robbins/ medieval-alexander.

[2] E. Baynham, "A Baleful Birth in Babylon: The Significance of the Prodigy in the *Liber de Morte*—An Investigation of Genre," in Bosworth/Baynham, 249. Alexander was himself an adept observer of myth, in persons and

Such documents, many of them going back to traditions recorded or invented in the century or so after Alexander's death, would provide writers and artists with a corpus of tales about the mystic east which were to echo in later centuries through the works of Marco Polo, the stories of Sinbad the Sailor, and Sir John de Mandeville's record of imaginary journeys in the east,[3] and much else. These are graphically recalled for us on many a Mappa Mundi—for example, the skiapods whose one giant foot protects them from the sun, the animal-men. In antiquity the stories were eventually written down and many different versions are known, the variety being dependent on their sources or on the religious, social and political aura of the time. The Greek version was the source of all the mediaeval versions in European languages in Europe, while the Syriac translation was the source of all the eastern. Some served as pure propaganda. Much, for instance, was gleaned from an imaginary *Letter to Aristotle on India*, which was perhaps composed, in Latin, as early as the seventh century.[4] "I would not have believed there could be so many wonders on the earth if I had not seen them first with my own eyes. . . . First I shall tell you about the things I saw, lest it should be said that all this is a fable and I am a liar. . . . I have established a new and durable record for heroic feats, which will both convey my

places; see R. Lane Fox, *Travelling Heroes* (London: Penguin, 2008), 185–191.

[3] In chapter XXXII, he places the Brahmans on islands called Bragman and Oxidrate and knows of the Trees of the Sun and Moon, in the empire of Prester John. Mandeville got the detail of travelling from books, not experience.

[4] Stoneman, *Legends*, xxii–xxiii; and in *Life*, 73–77.

fame to future ages and allow you, my master, to be acquainted with my care for you, my intelligence, and my dedication." And there was another early, fifth-century work, by Bishop Palladius[5] on eastern matters—*On the Life of the Brahmans.*[6] Versions of the Romances reached far to the east, even China, and Alexander was known to the Mongols by the fourteenth century, thanks to the diffusion of the stories from the Arab world and the Syriac version.[7] The seventh-century Byzantine writer Theophylactus has him found Mongol China (Taugast), while a late Persian romancer (Nizami) has him oversee a painting competition there.[8]

The Romances were by no means the only tales of antiquity, historical or mythical, that were written in the Middle Ages. But in common with them much of the material was derived from the eastern world, even Persia.[9] My approach to them here will not be only by their sources—Greek, Coptic, Armenian, Ethiopian, or many others—but for some stories a separate discussion seemed desirable. We follow them through the Middle Ages, but not beyond, when they become part of the Alexander "history" and are subjects for

[5] Ibid., 34–56.

[6] Ibid., xxv–xxvi.

[7] See F.C.W. Doufikar-Aerts, "King Midas' Ears on Alexander's Head: In Search of the Afro-Asiatic Alexander Cycle," in Stoneman et al. 2012, 61–79; and D. Zuwiyya, "Al-Tabari's Tales of Alexander: History and Romance," ibid., 205–218; and the *History of Al-Tabari*, discussed by El-Sayed M. Gad, "Umāra's Qissa al-Iskandar as a Model of the Arabic Alexander Romance," ibid., 219–231.

[8] Stoneman, *Life* 35–36.

[9] See R. Beaton, *The Mediaeval Greek Romance* (London: Routledge, 1996); for the east, 20–21, 208.

any artist or writer, and for later chapters. Only the Persian and Indian are here considered under separate headings. Thus, I start with stories about his birth and love life; and then go on to consider the stories of his aeronautics and his descent into the sea, which became immensely popular in the west. I quote often from the fullest version, in Greek, probably of about the third century AD, but surely embedding much from other, earlier accounts. But there are versions in texts of many different eastern languages—Aramaic, Coptic—and in European, including French, Italian, and English. I quote often from Richard Stoneman's translation of the Greek version (1991): he has been a most active scholar in this field of literary research, and several books attest his command of the material.[10] But he has not been alone. "The Alexander Romance as a subject for research rather resembles the Holy Grail—once get involved and you tend to sink without trace"—was D. J. Ross' opening comment to a volume collecting his important essays on the subject, which appeared between 1952 and 1982.[11] It is notable that French and English versions are often the more

[10] Stoneman 1991. He has edited the texts of several Romances, with translations (in Italian) by T. Gargiulo in three proposed volumes (1–2007; 2–2012), of the Fondazione Lorenzo Valla's series *Le Storie e le Miti di Alessandro*. See also the essays in Zuwiyya, *Companion*, notably R. Stoneman "Primary Sources," 1–20. In the Coptic version, see L.S.B. MacCoull, "Aspects of Alexander in Coptic Egypt" in Stoneman et al. 2012, 255–261. His *Legends* dwells largely on the east. See also F. Pfister, *Alexander der Grosse in den Offenbarungen der Griechen, Juden, Mohammedaner und Christen* (Berlin: AkademieVerlag,1956).

[11] Ross, *Studies*. Ross also edited George Cary's study on *The Mediaeval Alexander* (Cambridge: Cambridge University Press, 1956), which is a detailed commentary on the western European versions and texts rather than their content.

complete, and they offer evidence that invention about the adventures of Alexander did not cease with antiquity. An early fourteenth-century English "King Alexander" is based on a late twelfth-century Anglo-Norman 'Roman de toute chevalrie' including a conquest of Carthage (!) and the wonders of the east. An English fifteenth-century prose version[12] gives us the encounter with King Dindimus, after meeting the gymnosophists in India. Dindimus denounces him as a thug; Alexander replies in like kind and they part, Alexander having erected (yet another) column.[13] Study of the illustrations to the Romance take us even farther afield, from mediaeval Britain to the present day, and early ones can provoke speculation about origins that go beyond and even long before Alexander himself. These I reserve for the next chapter. Studies about the interrelationship of the various versions are more about literary scholarship than about Alexander, so I need treat only the most popular and imaginative stories, considering their possible origins and how they are exploited, mainly by artists. I am an archaeologist/art-historian, not a manuscript-lover. Inevitably, this account is incomplete. But the Romances can offer everything and more than you need to know about "Alexander," even his last will and testament.[14]

[12] Bodley MS 254. And see J.S. Westlake, *The Prose Life of Alexander from the Thornton MS.* English Text Society (Kegan Paul and Oxford University Press, 1911); D. Ashurst, "Alexander Literature in English and Scots," in Zuwiyya, *Companion* ch. 11. Stoneman, *Legends* xxvii, 57–66.

[13] On Dindimus and his *Correspondence* with Alexander see Stoneman, *Life* 105–106.

[14] D. Grant, *In Search of the Last Will and Testament of Alexander the Great* (Leicester: Troubador Publishing, 2017).

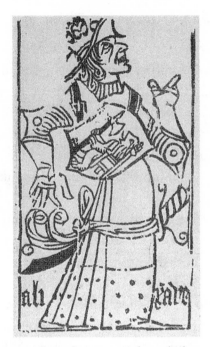

FIGURE 18. Alexander on a mediaeval playing card figuring "Worthies."

In the mid-tenth century AD, Archpriest Leo of Naples had translated Pseudo-Callisthenes into Latin, and this was one important source for Romances, with additions from others in other languages. In the thirteenth century, it was translated into Old French, in prose, where Alexander takes on all the trappings of a courtly character. Wauquelin's version is important and offers as full a version of his life and adventures, including Amazons and India, as any.[15] Apart from the Romance versions of his life and afterlife, Alexander was set to become one of the Nine Worthies, or Three

[15] *Les faicts et les conquests d'Alexandre le Grand de Jehan Wauquelin, XVe siècle* (ed. S. Hériché, Geneva: 2000), and its translation by N. Bryant.

Good Pagans (with Pompey and Charlemagne), of the Middle Ages,[16] and as well as the many illustrations of his deeds he could appear alone, with other ancient "Worthies" such as Caesar and Hannibal, for instance on the back of playing cards (fig. 18).

His Parentage

Alexander's birth was a subject for speculation by authors attempting to explain his apparently divine character and his almost superhuman behaviour. It was said that his mother Olympias bore him as the result of the attentions of a serpent, which was either the god Zeus in disguise, or the Egyptian king Nectanebo. There were even legends that Alexander was of Persian royal descent, and that Philip II of Macedon was not therefore his father. No one suggests a mortal Greek father.

There were many stories current even during Alexander's life about his birth, since a figure that might be deemed divine could have no ordinary origins.[17] Formally, he was son of Philip II of Macedon by his wife Olympias, but this was not enough, and historical doubts were embellished by romantic ones. There was something of the demigod hero Hercules about him, which required some closer connection to the divine, and it is clear that Alexander himself thought that he had some sort of divine relationship to the hero. Tertullian, writing around 200 AD, alleges a source,

[16] Ross, *Studies*, 266–287.
[17] Ogden, *Alexander* offers all references and copious translations of sources. Relevant iconography is more scattered but cited here. Overall, see Stoneman, *Life*, ch. 1.

contemporary with Alexander, for the story that Philip sealed Olympias' womb with a lion device. The story gets confused with other legends about his birth, to the point at which the seal can seem to guarantee that the child was a son either of Zeus or of Hercules, who was himself a son of Zeus, symbolised by his lion skin and cap, also to be adopted for Alexander, on coins especially. More direct intervention by Zeus lies in the story we meet in Plutarch that Olympias' womb was struck by lightning, the thunderbolt being peculiarly a weapon of Zeus. Even more widespread were the tales that a snake or snakiness was involved in the conception, the snake having an obviously phallus-like form as well as otherworldly connotations. Olympias was said to have been fond of snakes. Livy, a Roman author, writing about Jupiter (26.19.7–8), said that Alexander was conceived from intercourse with a snake, and that one had been seen in Olympias' bedroom.[18] (Comparable stories were to be invented about the birth of Octavian, another admirer of Alexander, who became the first Roman emperor, taking the name Augustus.) Alexander himself certainly trekked west in Egypt to the shrine of the ram-headed Zeus Ammon, who had long been known to and respected by Greeks, as their Zeus. There he was told that he was a son of Zeus, and thereafter the Ammon horns were adopted for much Alexander portraiture and were almost a permanent feature, and were certainly preferred to anything at all serpentine.

[18] I wonder whether the snake imagery could have been inspired by classical groups of Leda receiving onto her bosom the long snaky neck of Zeus as a swan.

There is another Egyptian connection, however. Alexander could also often be presented as a child of the Egyptian king Nectanebo, the last pharaoh of Egypt (reigned 360–343 BC), who, as we have seen, could certainly be associated with stories of the treatment of his body and is especially favoured in Greek versions of the Romances, as well as elsewhere. He too could be turned into a snake for the conception. In real life, he was twice defeated by the Persians before Alexander came, so there was plenty of room for romance about his career, especially as a wizard. The fourteenth-century English poet and friend of Chaucer, John Gower, made much of the conception story in his *Confessio amantis* IV.[19] We shall return to Nectanebo.

His Wives and Lovers

Alexander's sexuality was a common topic for ancient authors who were living long enough after him to be able to be imaginative in their handling of the traditions, let alone of the truth (whatever that may have been). The subject has been exhaustively studied recently, by Chugg, *Lovers* and by Daniel Ogden, *Alexander*. So much of a highly imaginary character was being told about him even during his life, to help explain his exceptional achievements, that his ancient biographers had a rich choice of anecdotes, to be improved upon and added to in the later Romances.

Alexander's greatness did not on the whole extend to his love life. Barsine was his first consort, not wife—a Persian princess whose father, a governor (satrap) of Phrygia, had

[19] Ibid., 37–39.

rebelled against Darius and was exiled with his family to Macedonia, where Barsine met Alexander. Their child was called Hercules, not in itself a claim to divinity, and Barsine remained with him to the end, it seems. We hear much about her, but little about her child. She had been married twice before—to Greeks—which may have encouraged Alexander later to promote more east-west marriages. This could well be part of a real tradition and one of the few of which he might have felt proud. In the east he married Roxane, but this was probably at least as much a political convenience as anything romantic, although it was strongly alleged by many sources that she was the love of his life. She was a Bactrian princess, daughter of the king of a rock fortress in Sogdiana (Central Asia) that Alexander had stormed. Her father Oxyartes was also favoured by Alexander. Roxane bore him a son, but only after his death, and was taken back to join the Macedonian royal family by Antipater in 320 BC. She did not attract very much attention from other ancient writers, and really becomes a subject for artists only with the Renaissance, but we may suspect that she was important to the young conqueror.[20] We shall meet her again, although she was mainly ignored as a major player in the story until modern films. One wonders whether the real Alexander's affections were not more taken by his companion Hephaistion, a Patroclus to his Achilles (a measure of homosexuality was acceptable for such a "Greek" hero); or even by his horse, Bucephalus.[21]

[20] On her relatively shadowy personality, see S. Müller, "Stories of the Persian Bride: Alexander and Roxane," in Stoneman et al. 2012, 295–309.
[21] On his relations with Hephaistion and the hunting *ethos*, see O. Palagia,

Of more interest to antiquity and later authors and artists was an affair which centred on his relationship with his tutor Aristotle, and here we turn to stories of the same pedigree as the Alexander Romances. It may, however, be preceded by an early account, by Pliny in the first century AD, of Alexander's mistress Campaspe (also known early on as Pancaspe). When Alexander visited the painter Apelles, as he did often, and was several times painted by him, he also had him paint Campaspe. He noticed that the painter had fallen in love with her and, magnanimously (or through relative indifference), allowed Apelles to take her. Later authors and artists liked the story, notably the English poet John Lyly (1553–1606), who wrote a comedy, *Campaspe*, in 1584. "O Campaspe, art must yield to nature, reason to appetite, wisdom to affection"; "Go, Apelles, take with you your Campaspe, Alexander is cloyed with looking on that which thou would be best at" and Apelles' song reaches all the anthologies:

> Cupid and my Campaspe play'd
> At cards for kisses—Cupid paid.
>
> At last he set her both his eyes,
> She won, and Cupid blind did rise.
> O love! Has she done this to thee?
> What shall (alas!) become of me?

But this is relatively recent comment, and we shall have to return to some elements in the Alexander Romance, which

"Hephaistion's Pyre," in Bosworth/Baynham, ch. 6. Also, Chugg, *Lovers*, ch. 3.

may go back even to near the days of the great man himself. But not quite yet, because there is one story of his early days, which was invented only in the Middle Ages, that is aimed rather at his alleged tutor, the Greek philosopher Aristotle, than the prince. It involves Alexander's mistress, Phyllis. The general argument seems to be that the influence of the tutor Aristotle on the young prince was beginning to seem unduly great, and the need was seen—by someone, perhaps Phyllis herself—to cut him down to size, and show that a great scholar was as prone to human failings as any man. So she seduced Aristotle and made him carry her around the garden, seated on his back, with the sage on his hands and knees and Phyllis holding a whip.

The story was a creation of the Middle Ages, not antiquity. The sage on all fours carrying the tart became nearly as familiar a subject, but surprisingly, in the same ecclesiastical settings, as was the image of Alexander's Flight (our next subject). It appears painted on the walls of Christian buildings throughout Europe. It is not very easy to see how it was explained to worshippers, unless the frailty of mortal pre-Christian sages was being mocked in comparison with that of true divines. There is a splendid example in the round as an aquamanile in New York (plate 7),[22] where she slaps his bottom, and several other versions are reproduced in woodcuts, such as the one in the fourteenth-century cathedral at Lyons.[23] The German artist Hans Baldung Grien (1475–

[22] Copper alloy. South Lowlands, late fourteenth century. Met. Mus. Lehmann Collection 1975.1.1416.
[23] A good account of the whole episode by George Sarton, "Aristotle and Phyllis," *Isis* 14 (1930): 8–19, with illustrations.

FIGURE 19. Phyllis rides Aristotle. Woodcut by Hans Baldung Grien, 1510.

1545) has a detailed study, that also shows them both naked, which is uncommon for the subject but obviously appropriate. But he also drew a more conventional dressed version (1503) (fig. 19). A fifteenth-century wooden tray in the Victoria and Albert Museum, made in Florence by Apollonio di Giovanni in the 1460s, has a Triumph of Love, with a small group of Phyllis riding Aristotle discreetly included.

The image has a silly later history, used by the Mexican nineteenth-century artist Julio Rielas, but renamed for Socrates. And there were also Socrates versions, nude and dressed, by or after the seventeenth-century French artist

Henri Gascard, who worked in England and probably simply got the story wrong.

We have already had occasion to notice Alexander's affair with an Amazon queen, Thalestris, and there were some ancient authors who alleged a relationship with the eunuch Bagoas, who had been an intimate of Darius, an episode taken up in modern times by Mary Renault.[24]

His Horse Bucephalus

Plutarch is the first to mention the horse, a black, the gift of Demaratus, or bought by Alexander's father Philip but said to be untamable. Alexander saw that the creature was frightened by its own shadow, so he turned him to the sun and thus managed to tame him. The horse's mark, or *tamga*, was a bull's head, or perhaps just a flash on the forehead, although artists soon decided that he must have been in fact horned and is shown as such on some coins; it helped the story that he was divine, wild and a man-eater, but he would kneel for Alexander to mount. Other origins for the horse than Thessaly were named, notably Cappadocia, making him an easterner. Naturally some magic crept into the story, as that he was born of one of Philip's mares who had drunk water from Nectanebo's bath. The Hellenistic statue of Alexander on a rearing Bucephalus was to be much copied by Renaissance and later artists in depictions both of Alexander himself and of other "heroic" figures, notably St. George and the dragon as well as real heroes.

[24] For Thalestris and Bagoas see Chugg, *Lovers*, 155–163, 144–154.

His Ingenuity

Two fantasy adventures offer a special display of Alexander's ingenuity and invention,[25] closely associated with his training at the feet of the greatest savant of all time, Aristotle. These are best followed in the Greek version of the Romance, probably composed in, or by, the third century AD. Variations of the stories told here appear in other versions, more devoted to the local interests of those who composed them. For our purposes, the Greek version will introduce us to most of the stories that occupied mediaeval and later writers and artists. One of the most famous was about Alexander as aviator, desiring to see the whole world, having already conquered as much of it as was available to him:

THE FLYING MACHINE

> Then I began to ask myself again if this place was really the end of the world, where the sky touched the earth. I wanted to discover the truth, and so I gave orders to capture two of the birds that lived there. They were very large white birds, very strong but tame. They did not fly away when they saw us. Some of the soldiers clambered on their backs, hung on tightly and flew off.... On the third day I had something like a yoke constructed from wood, and had this tied to their throats. Then I had an ox-skin made into a large bag, and climbed in, holding two spears, each about 10 feet long and with a horse's liver fixed to the point. At once the birds soared up to seize the livers, and I rose up

[25] Cf. Stoneman, *Life*, ch. 6.

with them into the air, until I thought I must be close to the sky.[26]

The most fantastic stories of this type do not always spring from the imagination of a single author, however inspired, then to be embellished by followers, translators and illustrators. In this case, both the story and the iconography used for it in its earliest days betray the possible influence of earlier stories and pictures in the world of the Near East, where flying gods and heroes were commonplace Particularly relevant are early Mesopotamian images of earth-deities feeding animals from branches that they hold to either side of them. Later, in Syria/Palestine, there are many pictures of kings and gods seated on thrones that have big winged creatures as side pieces. It was not difficult to combine the two into an image of the god lifting his throne by persuading the winged monsters to rise. Later too, in Sasanian Persian arts, the king is often shown on a bench that is being lifted skyward by the winged animals or monsters that are its supports.[27] In later Persian myth Jamshid (builder of Persepolis, i.e., Darius) sat on a jewel-studded throne and his "divs" (demons) raised it into the air and flew. In Roman art, a god in a chariot may be shown frontally with the beasts that draw him along climbing the sides of the circular fields in which he is placed, which is a good model for several Alexander images, which appear throughout Europe in the Middle Ages, from Britain to Georgia, commonly on sacred build-

[26] R. Stoneman, *The Greek Alexander Romance* (London: Penguin, 1991), 123; idem in *Life*, 108–120, also for the diving.

[27] For these, see my article "Alexander the Great's Flying Machine," *AWE* 14 (2015): 313–322.

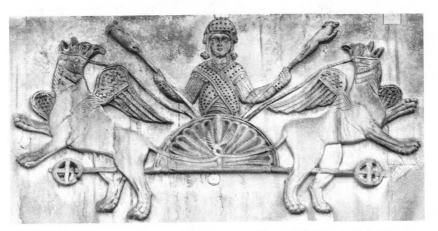

FIGURE 20. Alexander persuades two griffins to lift him. St. Mark's Cathedral, Venice. Photo by author.

ings. He is expressly named in a floor mosaic in Otranto's twelfth-century cathedral (plate 5).[28] A rendering more like the Roman models appears in St. Mark's, Venice (fig. 20).[29] Victor Schmidt has made a fine assembly of pictures of the image and commentary upon them in his book of 1995. In many scenes the figure is on a chair or chariot with the creatures veering away below and beside him. Later he is given a more comfortable seat in what looks more like a sedan chair or carriage with windows, or it may be simply a cage or a great throne, the carriage corresponding best with the description of the event in Alexandre de Paris' version of the tale.[30] One of the remotest and earliest examples was not known to Schmidt—it seems to be an early Byzantine

[28] V. M. Schmidt, *A Legend and Its Image* (Groningen: Egbert Forsten, 1995), fig. 1. R. Morosini, "The Alexander Romance in Italy," in Zuwiyya, *Companion*, 329–335.
[29] Schmidt, *A Legend and Its Image*, fig. 13.
[30] Ross, *Studies* 247.

silver bowl from the Urals area, with Alexander on a stool and two leaping griffins.[31] And one cannot forget that the so-called Alfred Jewel in the Ashmolean Museum, Oxford, carries a bust of Alexander, holding the usual branches, and signifying Sight, for a pointer (*aestel*) to help in reading manuscripts (plate 6).[32]

THE DIVING BELL

Alexander had made for himself a large glass jar which could be lowered into the sea and from which he could gather material from the ocean bed.

> When everything was ready I stepped into the glass jar, ready to attempt the impossible. As soon as I was inside, the entrance was closed with a lead plug. When I had descended 180 feet, a fish swam by and struck the cage with its tail. At once the men hauled me up, because they had felt the chain shake. The next time I went down the same thing happened. The third time I got down to a depth of 464 feet, and saw all kinds of fish swimming around me. And behold, an enormous fish came and took me and the cage in its mouth and brought me to land a mile away. There were 360 men on the ships from which I was let down, and the fish dragged them all along. When it reached land, it crushed the cage with its teeth and cast it up on the beach. I was gasping and half-dead from fright. I fell on my knees and thanked Providence above which had

[31] *Sokrovshcha Probya* 1996, 149–161, fig. 2.
[32] See above, n. 27.

saved me from this frightful beast. Then I said to my-
self, "Alexander, now you must give up attempting the
impossible, or you may lose your life in attempting to
explore the deep."[33]

This was easier to depict but less popular in European art
than the ascent to the heavens. Alexander is generally shown
in something like a barrel, and the major point of interest is
the wild life seen around him. This includes even the an-
thropoid in a fourteenth-century northern European draw-
ing in Berlin.[34] We find the subject more often shown in the
east, but rarely in later European art.

His other fantastic eastern adventures did not attract Eu-
ropean artists in the same way. And for the products of his
other brainwaves, Pseudo-Aristotle tells us how he devised a
gold magnet when he was in the eastern Valley of the Dia-
monds, here borrowing Aristotle's own skills, since he had
published a monograph on stones. His other abilities apart
from the military, were as a judge, as a designer of towns,
and as a philanthropist.

The Other Romances

These two very popular adventures, the flying and the div-
ing, were obviously deemed to have taken place long after
the campaigns leading to the death of Darius, but, it seems,
before Alexander's main Indian campaign, thus corre-
sponding with his real march north into Central Asia, to-

[33] Stoneman 1991, 119. Ross's Inaugural Lecture, *Alexander and the Faithless
Lady: A Submarine Adventure*, appears in Ross, *Studies*, 382–402.
[34] Schmidt 1995, fig. 71.

wards the steppe. The Greek versions of the Romance are, understandably, among the earliest, well studied in Veloudis, *Alexander.*

One Greek version is available in English translation by Stoneman.[35] It derives from manuscripts going back to the tenth century AD and is the source of my quotations about the flying and diving, given above. It tells us that he eventually turned north (towards the Plough constellation) where he found a forest of trees called *anaphanda*, with fruit the size of melons. Mystic trees figure large in the Alexander stories as well as in other eastern literature, and they must reflect some notable real examples long visible and venerated.

Soon he was attacked by giants called Phytoi, thirty-six-feet tall, then by some spherical giants, and then by the Ochlitae who were of normal size but hairless and "broad as a lance." He fought them, then visited their caves, guarded by three-eyed lions and fleas as big as frogs. In the land of the Apple-eaters they found a hairy giant who ate a woman they brought to him; then he fought an army of men who had no human intelligence but barked like dogs. Eventually he found the cave where Greek gods and kings were imprisoned—Kronos and Hermes, in chains, a very odd distortion of Greek myth.

Thereafter the number of marvellous beings and adventures multiplies, often the product of pure fantasy on the part of the authors and often with little regard for geography. It is not surprising that mediaeval artists found so much to occupy themselves with in Alexander's adventures. I do not attempt to mention all of them, but they are a tribute to the imagination of their authors. Trees were as important as

[35] Stoneman 1991.

monsters—trees that could grow and diminish in a day. On wild animals, any number of eyes and legs seemed possible. Of the inanimate, there were some black river stones that turned you black when you touched them. In the Land of the Blessed the sun did not shine, but then there was a Land of Darkness and a spring that gave immortality, from which, alas, he did not drink. Two birds with human faces advised him to go back before it was too late.[36] There is no good reason to think that the real Alexander sought immortality rather than unlimited power, and immortality issues in the Romances are mainly a sideline. They are most prominent in eastern versions, copying Gilgamesh or encouraged by Arabic and Indian stories.[37]

The Greek Romance had supplementary stories too of his life and afterlife. These include his encounter with Scythians in the north; his travels west, even to Rome; travels south to meet large and hostile women; and his visits to Judaea where he was impressed by the Jews and to Egypt (as a "son of Nectanebo"). There were further adventures "in the Interior."

His Indian campaign goes well, but there he meets the naked Brahmans, and this might be some sort of recollection of an historical event. The fifth-century AD Spanish Christian historian, Orosius, paints a grim picture of Alexander's behaviour in India with the Brahmans, an attitude echoed by many later Christian writers who perhaps resented his eventual respect for pagan thinkers.[38] Their an-

[36] Talking birds are a feature of many Romances, sometimes associated with magic trees. See Stoneman, *Life*, 5–8, for some examples.

[37] Stoneman, *Life*, 150–154.

[38] A. T. Fear, "Alexander and the Virtuous Indians," in Prabha Ray/Potts, *Memory*, 40–53.

swers to his questions were all too rational,[39] as were those of the two talking trees (male Sun, female Moon) in a forest, who foretold the manner of his death. He writes a friendly letter to the queen of the Amazons, who replies explaining their customs, and with a warning, but they admit him to their lands on the Thermodon River and pay a tribute of 100 talents of gold each year. Thereafter, there are the dog-headed men and men with eyes in their chest such as will infest travellers' imaginations for centuries. Thus, the men with their heads in their chests appear in a number of mediaeval illustrations and most Mappae Mundi, and they seem related to the semi-historical Blemmyes, fought by Romans in the Sudan in the second/third centuries AD. India was a particularly good source for strange animals, it seems—giant scorpions, ants bigger than lions, men with six hands.

On then to an island with the City of the Sun, topped by a gold and emerald chariot group. A temple is adorned with what is clearly Bacchic pageantry, and a vocal bird tells him to go home "and not to strive to climb the paths of heaven." But this turns out to be the palace of the Persian king, Cyrus, and what remains to tell is of Alexander's death and will. Supplements to the Romance have Alexander conquering Rome—not a common theme, understandably in historical terms, but there was more of what occupied other versions of the Romance. This includes his visit to the Jews and Egypt. The monsters he meets can sometimes be related to those conceived by other cultures, but many are sheer invention—women covered with long hair like pigs, hairy black

[39] On the Brahmans, see R. Stoneman, "Naked Philosophers: The Brahmans in the Alexander Historians and the Alexander Romance" *Journal of Hellenic Studies* 115 (1995): 99–114; idem, *Life* ch. 5.

men. More becoming are the two gold statues identified by Alexander as of Hercules and Semiramis, and the latter's deserted palace. The monster larger than an elephant, called Odontotyrannos, fell into flames but emerged from them to kill 26 men at once, and, overcome by Alexander's men, required 1300 men to drag its body away. Such tales feed the stories about the legendary Prester John. By setting up a mirror Alexander thwarted the basilisk whose glance could kill.[40] In this he copies the Greek legend of Perseus' ruse to get at the gorgon Medusa, whose glance could kill. I return to the Greek Romance derived from Persia and known as the *Phyllada* below, and to the Renaissance and later reflections of our man.

Other versions of the Romance in other languages dwell on these and similar episodes in various ways, all inspirational to mediaeval artists. I have to be selective. An early prose version is French, *Le Roman d'Alexandre*, and there are others, generally well illustrated, of the fourteenth and fifteenth centuries.[41] We have had occasion to mention French versions already. They seem singularly adept at creating moralizing messages from the story. Harf-Lancner picks out the way Alexander is presented as an image of ideal royalty—a "Mirror of Princes"; for his generosity as well as cunning; for his alliance with the clerical (Aristotle); as a "Mirror of the Orient" for his obsession with eastern stories of sages, immortality, magic trees, and the monstrous. Yet also there was "Immoderation," vertical

[40] An Italian has Alexander use his diving bell as protection for his approach to the basilisk: R. Morosini, "The Alexander Romance in Italy," in Zuwiyya, *Companion*, 350.

[41] L. Harf-Lancner, "Medieval French Alexander Romances," in ibid., ch. 9.

conquests (the flight and descent in the ocean), and his choice of Babel (Babylon) for his coronation and death. The French versions carry the Nectanebo stories for his birth, his miraculous generalship and compassion for Darius, and his obsession with the orient.[42]

In Spain there was *El Libro de Alexandre* in the thirteenth century, with unusual illustrations:[43] one with Alexander standing at the tomb of Achilles at Troy, the other showing Alexander's near-death experience bathing in the River Cycnus. Arab (Moorish) rule in Spain began in AD 711, and with it the introduction of the eastern interest in Alexander stories.[44] The results were relatively original—a poem, the *Librero de Alexandre* and a prose *Historia novelada de Alejandro Magno*. The first presents him as a chivalric knight in some 10,000 verses; the *Historia* follows his career in the manner of most eastern romances.

In England[45] Sir Thomas Malory's *Morte D'Arthur* knows of "the mighty conquerroure," as does a late Anglo-Saxon poem, *Widsid*, and the Old English *Orosius,* which is more critical of him. Middle English verse romances offer a *Kyng Alexander* in the early fourteenth century, in rhyming couplets, with no little sympathy for his feelings rather than his deeds—for instance his forbearance with Candace:

> Many nizth and many Day
> Bus hij duden her play—

[42] For the French fourteenth-century *Roman de Renard* and its picture of Alexander's birth and life, see Ross, *Studies*, 365–376.

[43] Ibid., 376–381.

[44] Z. D. Zuwiyya, "The Alexander Tradition in Spain," in Zuwiyya, *Companion*, ch. 10.

[45] D. Ashurst, "Alexander Literature in English and Scots," in Zuwiyya, *Companion*, ch. 11.

> In halle at table he sat hire by,
> In chaumbre gest, in bed amy.

And alliterative accounts inform other fragmentary poems:

> I bat was zustirday so yape & yemed all be werld,
> Today am dreuyn all to duat, to dolour & paynes.

In Scotland there were fourteenth-century rhymed versions of some poignancy:

> To Babylon syne can he ga.
> Allace! Allace! Quhy did he sa?
> He deit thare throw poisoning;
> It was great harme of sik ane thing,
> For neuer mare sik an lord as he
> Sall in this warld recouerit be.

German romances are relatively late on the scene,[46] and seem generally prepared to give their subject most benefits of the doubt about his character. The thirteenth-century romance by Ulrich von Etzenbach[47] gave events a courtly setting honouring the king of Bohemia, Ottokar II, whom he could identify with Alexander. It includes an engaging account of Alexander meeting the dwarf king Antilois, who could render himself invisible.[48] Johann Hartlieb's prose *Alexander* of the mid-fifteenth century enjoyed a wide success. In Italy there was an extensive rewriting of the Alexander story in the thirteenth and fourteenth centuries—the age of Marco Polo—with less chivalry than in France and more

[46] D. Buschinger, "German Alexander Romances," in Zuwiyya, *Companion*, ch. 12.
[47] Ross, *Studies*, 288–295.
[48] Ibid., 296–311.

attention to eastern adventures.[49] Quilichino's *Historia Alexandri Regis Macedonum* of the thirteenth century was influential and dealt with his subject very much as he might have done with any European monarch.[50]

The Balkans were Alexander's home, but his Romances there have to come from far to the east, though they become well accommodated for bolstering local western tradition. The *Alexandrida* translated into Slavonic/Serbian and Bulgarian in the fourteenth century, and Romanian in the sixteenth, was based on the earliest, which dwelt no little on Alexander's life as well as on the Romances. In the western Ottoman world, which embraced Greece and much of the Balkans, the eastern *Iskandername* was the model (see below), but he was not unknown to mediaeval Turkey.[51] Naturally, the port of Alexandretta in Turkey becomes Iskenderun.

We turn east again, to Israel. Gog and Magog are giants, hostile to Israel, and they appear in the Jewish Alexander Romance, and occasionally elsewhere.[52] They lived in Central Asia, often located at the Caspian Gates of Derbent (the southeast corner of the Caspian Sea), but in the Romances the Gates are commonly shifted west, to the Caucasus. The

[49] R. Morosini, "The Alexander Romance in Italy," in Zuwiyya, *Companion*, 335–340.

[50] Ibid., 341–343.

[51] H. Boeschoten, "Adventures of Alexander in Medieval Turkish," in Stoneman et.al. 2012, 117–126. At Priene are shown the ruins of the house where Alexander stayed en route to Miletus.

[52] A.R. Anderson, *Alexander's Gate, Gog and Magog, and the Inclosed Nations* (Cambridge, Massachusetts: Mediaeval Academy of America, 1932), supporting a Jewish origin for the Gog/Magog story. Sverre Boe, *Gog and Magog* (Tubingen: Mohr Siebeck, c2001). Stoneman, *Life* 176, 184.

giants are recorded in the Bible (*Exekiel, Revelation*) as well as the *Koran,* and Alexander is named for building a wall of steel to fend them off. In the early Middle Ages, this could be the abode of the Lost Tribes of Israel (which, in other stories, are rescued by our Alexander). But the Bible takes a different view. "And when a thousand years are finished, Satan shall be loosed from his prison, and shall go out to seduce the nations which are in the four corners of the earth, Gog and Magog, and shall draw them to battle, whose number is as the sand of the sea" (*Revelation* 20.7–8), as do Moslem sources. In many other ways, the giants seem correlated with well-known nomad tribes, like the Scythians. The story and geography are as confused as they can be, but the subject attracted mediaeval artists and writers who named the "Gates of Alexander." There was also certainly some confusion with the Great Wall of China, and with Tartars and Mongols. In the Greek Romance there are two mountains side by side, which he joined with gates, with a desert beyond—a version of the Caspian Gates.

We should not be surprised at a Jewish interest. In the Old Testament, *Daniel,* chapter 8, includes a rather confused interpretation of his dream of the encounter of a ram and a goat: "that ram that you saw with the two horns, these are the kings of Media and Persia. And the goat is the king of Greece. And the great horn between his eyes is the first king." Israel's peripheral dealings with Alexander do not hinder some storytelling, vaguely historical. Josephus' *Antiquitates Judaicae* 11.8, has Alexander visit Jerusalem after taking Gaza.[53] The High Priest Jaddua goes to meet him,

[53] On his favourable reception in Jerusalem see Stoneman, *Life,* 49–52.

and Alexander pays homage to his God, offering sacrifice in the approved manner. He explains this by having seen Him in His priestly dress in a dream he had in Macedonia. He permits the Israelites to enjoy their ancestral laws, even those who enlisted against him, and exempts them from tribute—a privilege denied the Samaritans whom he delivers up to Israelites. Generally, Hebrew translations of the Romance derive from Arabic or Latin. The Jewish *Tamid* (Tractate) has other stories: his meeting with the ten gymnosophists, his journey into Lands of Darkness; and there is a version of his (not another observer's) discovery of the Well of Immortality by reanimating a dead fish dipped into it; his meeting with Amazons who bring him gold bread on a gold table, chiding him for his expedition when he could have his bread at home (a version of a non-Alexander story by Plutarch); and his arrival at the Gates of Paradise where he asks for a gift and is given a small ball (the "Wonderstone") which, weighed, was greater than all his possessions—in fact an eyeball, satirising his greedy ambition.[54] The *Tamid* also gives an account of his flying and diving adventures, and there are translations of the Greek Romances.[55] Some features are novel—he is circumcised, his army is kept alive with *manna*, a statue on his grave carries an apple symbolising his dominion over all the world; his mur-

[54] Stoneman, *Legends*, 72–74; *Life*, 166–167; Ross, *Studies*, 249–253, 264ff.
[55] S. Dönitz, "Alexander the Great in Medieval Hebrew Traditions," in Zuwiyya, *Companion*, ch. 2. On Jewish versions of the Romance, see O. Amitay, *From Alexander to Jesus* (Berkeley: University of California Press, 2010); idem, "Alexander in Bavli Tamid: In Search for a Meaning," in Stoneman et al. 2012, 349–365; A. Kłęczar, "The Kingship of Alexander the Great in the Jewish Versions of the Alexander Narrative," in ibid., 339–348.

derers escape to the fortress Arondil but are caught and tortured. Syriac versions of the story depend partly on the Jewish but also the Greek and Persian. Alexander prophesies the coming of Christ.[56]

For the Arabic tradition,[57] in the *Koran* itself Alexander is "the two-horned," Dhul-Qarnayn, referring to his assimilation to Zeus Ammon and wearing of the goat horns. The references are slight. He is a friend of God, perhaps a prophet. He visits the Far East and sees to the building of the Great Wall that will contain Gog and Magog. The stories follow the tradition in pre-Islamic Arab and Syriac storytelling, which dwells on these subjects. He is known as a "Roman" (i.e., Byzantine) and the founder of Alexandria. In the west, the *Rek* is a romance written in Aragonese Spanish, deriving from the Arabic version of perhaps the eighth century AD in North Africa, followed by others in classical Arabic, in which a pious Alexander can appear as God's designate to arrange the world, as in *Genesis*, or with Mohamed. He can adopt Christian parentage. The ninth-century 'Umara ibn Zayd wrote a full account, as did Al Súrí in the thirteenth century, with the expected travels drawing on the usual Arab sources. But it ends with Alexander building the Pharos Lighthouse at Alexandria. A witch engraves a sign on it and tells Alexander to leave, so he travels to Mecca where he is told that he will not die until he lies on gold and is covered with iron (which happens—a mail corselet and gold sheet covering), but the angel sent to carry him away spares him. He sends his treasure to his mother, but then

[56] K. van Bladel, "The Syriac Sources of the Early Arabic Narratives of Alexander," in *Memory*, 54–75.
[57] For a full account of the Arab sources; Stoneman, *Life* 154–162.

dies, perhaps poisoned. We should not expect any too coherent account in such stories gleaned from many sources and with original ideas inserted by the authors.

These Arab sources commonly tell the Alexander stories as through the mouth of Mohamed. There are several minor inventions, such as that his "horns" were simply two tufts of hair, and they dwell upon him as an explorer, to as far as India. Chinese, Mongolian, and Malayan versions are known, some going back to the beginning of Islam if not beyond.[58] Other contributions from Arabic literature are collections of *Sayings of the Philosophers*, which go back to the ninth century and depend largely on Greek sources. There was also, for the Arabs only, the figure of a prophet and friend of Alexander, al-Khidr ("the green one"), who sends Moses on a journey to a source or well out of which a fish escapes. A Syriac version has Darius mistaking Alexander for Mithras.[59]

The Romances seem to have had no boundaries to their interest. Go as far west as you can in Eurasia, and you even find a late Nordic version, a thirteenth/fourteenth-century saga written in Norse, which in some ways bids to embrace local legend.[60] There is also an abridged version of Alexander's *Letter to Aristotle*. An Old Swedish poem, *Konung Alexander*, was translated from Latin in the fourteenth cen-

[58] Y. Yamanaka, "The Islamized Alexander in Chinese Geographies and Encyclopaedias," in Stoneman et al., 2012, 264–274.
[59] See *Memory*, 58–60, 63.
[60] *Alexanders Saga: AM 519a 4° in The Arnamagnaean Collection* (Copenhagen: Museum Tusculanum Press, 2009). See the review in *Comptes rendus des séances de l'Académie (CRAI)* (2014), 1363–1364; D. Ashurst and F. Vita, "Alexander Literature in Scandinavia," in Zuwiyya, *Companion* ch. 13.

tury, and was original and influential in its treatment of Alexander.[61] Armenia has its version too and tells of Parnovaz (Pharnobazus, a real king of Georgia in the third century BC) who let Alexander through the "Caspian Gates" (Darial Gorge between Russia and Georgia, with the river Terek). Josephus had Alexander build the "Iron Gates" there. An Ethiopian version of his exploits also relies greatly on Pseudo-Callisthenes.[62]

Seriously, Though—Nectanebo?

The association of the Egyptian king Nectanebo II and his sarcophagus with Alexander, as his father and providing his final resting place, recurs in many Romances. Historically, their ages would fit. Even before he came to the throne, and certainly afterward, Nectanebo II had been busy trying to release Egypt from Persian rule, and he worked and fought beside Greek leaders—Agesilaus and Lamias of Sparta, Chabrias and Diophantos of Athens. In Egypt he conducted a very busy and productive building programme.

That he ever visited Greece is not recorded, but a trip is plausible, and he certainly travelled—fighting Persians at Tyre, for example. If he had visited Greece, he most plausibly might have gone to his allies there, and perhaps travelled on north to Macedonia, where Philip II was more effectively planning to attack the Persians than were any Greeks (until the Macedonians more or less obliged them to).

[61] Zuwiyya, *Companion*, 324–327.
[62] E. A. Wallis Budge, *The Life and Exploits of Alexander the Great: Translations of the Ethiopian History of Alexander by Pseudo-Callisthenes and Other Writers* (London; Leipzig [printed]: C.J. Clay & Sons, 1896).

Olympias, Alexander's mother, was a feisty woman, quite ruthless and self-willed, as her later career shows. That she might admit a regal Egyptian lover seems not altogether out of character. Stories of her impregnation involving snakes and snaky beings would suit the Egyptian royal image, where the cobra and various serpents were a prominent part of royal apparel and imagery. Even in Pseudo-Callisthenes Nectanebo disguises himself as Ammon with fleece, horns, and a gown resembling a snake.[63] Ammon too is mentioned in some of the stories. Nectanebo himself, we assume, would have been fairly black, with curly hair, kin to the usual African/Nubian/"negroid" type, of somewhat lesser stature than the average European male.

It is generally thought that after some inconsequential brushes with the Persians Nectanebo fled south, to Nubia, where he died. This is not altogether certain. He may well have returned, and a sarcophagus had been prepared for him, eventually coming to rest in Alexandria, but probably awaiting him in Memphis or possibly Sais.

It was remarked in antiquity that Alexander was slightly shorter than one might have expected of a prince-hero. He had unruly wavy hair, but so, to various degrees, did most of his family, to judge from coin portraits. He probably had fair hair and perhaps blue eyes, as did most Greeks and Macedonians—modern Greek appearance being affected by centuries of Ottoman presence. No one says that he was at all swarthy. His nose was prominent. So physical indications of Egyptian parentage are, to say the least, flimsy. His

[63] Ross, *Studies*, 363.

deep interest in Egypt and her gods is manifest, not least in the manner in which he went there so often, and in his prime ambition to clear Egypt of Persians before going on east, as well as his devotion to the god Ammon, whom he seems to have deemed his father in some measure. He was also anxious to make of him a purely "Greek" god—Zeus. And he did bother to found the first, greatest, and longest surviving of all his "Alexandrias" in Egypt. His other Egyptian adventures—knocking the nose off the Sphinx (otherwise deemed a deed of Napoleon's) are the product of fantasy—plus a little knowledge (that the Sphinx was noseless).

All this does not add up to making him a really plausible bastard son of an Egyptian king. Does it?[64]

[64] In mediaeval iconography Nectanebo enjoys possession of a great palace and garden at "Babylon"—the Egyptian Babylon—Old Cairo: Ross, *Studies*, 315–335, pls. 1–3.

V

The Persian Alexander/ Iskander

How much modern Persia/Iran might value Alexander is hard to discover, but the last shah, deposed in 1979, had been anxious to revive the Achaemenid Cyrus Dynasty and even its calendar, and he celebrated the 2500th year of the death of the Persian Cyrus, finding the heritage a justification for trying to expand his own empire. His bid was abortive, but earlier Persians were fascinated as much by the Macedonian as by their own (supposed) kin, and their literature and art are major sources for us.

The dismantling of the great Persian Achaemenid Empire had been Alexander's goal, one that he thoroughly achieved. After him the country was ruled by Macedonians (Seleucids), then Parthians (from Central Asia), and then Persian Sasanians who effectively kept Rome at bay. Persia became Islamic with the rest of western and central Asia in the seventh century AD, but its people were quite distinct in their genealogy and temperament from the Arab world. Their version of Islam was in a way more relaxed, their arts more tolerant of figurative decoration and splendidly colourful. Their destiny was to be quite different from that of Muslims to the west, from Mesopotamia to the Mediterranean, and

it remained as closely linked to the east as to the west. Look at any aerial view of the western world, and Persia is clearly the hub or pivot of Eurasian civilisation.

The land whose great empire had been destroyed by Alexander did not forget its conqueror and could even be more inclined to forgive him. Indeed, it proved to have the longest memory of antiquity, although not in the immediate aftermath of its defeat. There is virtually nothing of Alexander in Parthian story or art (such as there is), and Sasanian art appears to ignore him, often in favour of more "classical" subjects. In the years before the advent of Islam, there was knowledge of the Alexander Romances via the Pahlavi and Arabic versions,[1] but then two great compilations of Persian history gave him prominence, as also did artists. The *Iskandarnamah* was a rather rambling account of early Persian history and was subject to constant revision. The *Shahnameh* was compiled by Firdowsi in the early eleventh century AD in a more coherent manner, but was determined more by imagination than by recorded history (insofar as there was any, apart from the likes of "Pseudo-Callisthenes" and the Romances).[2] The poet Hafez (second

[1] Stoneman, *Life*, 31–32. Stoneman et al. 2012 has many important essays on the Persian tradition, and see the review by R. Kruk, "Review of Stoneman, Erickson, and Netton, eds.: The Alexander Romance ..." *JAOS* 135.2 (2015): 387–390.

[2] See M. S. Southgate, *Iskandarnamah* (New York, 1978), and the review by E. Naby, *Journal of Near Eastern Studies* 41.2 (1982): 152–154. There are useful essays on the record in Persia in Stoneman et al. 2012, esp. 319–323 (S. Asirvatham); and a broader account in V. S. Curtis, *Persian Myths* (London: British Museum Press, c1993). See also D. L. Selden, "Iskander and the Idea of Iran," in *The Romance between Greece and East* (eds., T. Whitmarsh, S. Thomson, Cambridge: Cambridge University Press, 2013), ch. 10;

in popularity today to Omar Khayyam as the "Persian poet" with an English flavor—thanks to translations) could refer to him with some familiarity.[3] Firdowsi's compilation was largely followed in a prose tale, the *Darabnameh*, by Abu Taher Tarsusi in the twelfth century, and then by others, especially Nizami.

A notable feature was the way the Persians created and presented an Alexander of part-Persian royal descent. His father became one Darab (=Darius), who was also ruler of Rhum, which he had conquered. Rhum was Anatolia, the nearest province of what was to be the Roman Empire. In the *Iskandarnamah* the ruler of Rhum, Filqus (=Philip), gave his daughter in marriage to Darab, but she fell ill and was sent back to Rhum where she gave birth to a boy destined, so promised the soothsayers, to rule the world. He was named Iskandar and taken for the son of Philip. His education was intense and, once he had succeeded Philip, he was a good lawgiver, but he knew of his real parentage from his mother. Darab's own son, another Darab, by an Indian mother, was father to a daughter, Rushanak (=Roxane). This Persian Alexander proceeded in his mission to conquer the whole world, but sought peace with Darab, who rebuffed him. Darab's capital Istakhr (the "modern" city near Persepolis) fell, and his new army was again defeated while he himself was killed by his attendants, in this respect very

H. Manteghi," Alexander the Great in the Shāhnāmeh of Ferdowsī," in Stoneman et al. 2012, 161–174, on sources. Stoneman, *Life* 24–26 and ch. 2.
[3] Ibid., 33–38. For Alexander in other Persian literature, see also Stoneman, "Primary Sources From The Classical And Early Medieval Periods," in Zuwiyya, *Companion*, 3–18.

like Darius. Before he died Alexander reached him and re-
vealed their kinship, seeking reconciliation. His body was
placed in a golden coffin, and Alexander set out for Oman
and further conquest.

The king of Oman (south Arabia, close to the sea route to
India via the Red Sea) gave him elephants, and Alexander
set off to confront the Indian king Porus, in this respect at
least respecting history. From this point on, the story traces
much of the ground and the encounters that form the sub-
ject of the other Romances, as well as much more. He exe-
cutes the Indian Porus, marries his daughter, and moves on
to Kashmir, where he also marries the king's daughter—
habit-forming—with the help of an intermediary—Aris-
totle (Arstatalis)—who does not commonly continue in his
retinue but has further missions for him in this version. He
converts the king of India, Kavd, to Islam. Thence to Cey-
lon, the Tomb of Adam, and the Garden of Eden—very Bib-
lical echoes here. He rescues Muslims from the Davalpayan,
who are the children of Adam, and performs the ritual Mus-
lim circumambulation at Mecca; thence to Yemen and to
Egypt where he defeats the king, but marries one of his
daughters. Thereafter Alexander can be taken as a servant of
Mohamed as much as of the Jewish Jehovah or the Chris-
tian Messiah. There is no more confused account of him
than the Persian.

Islamic Alexander inspired many new stories, some echo-
ing the traditional Romances. Candace appears, but in An-
dalusia (beyond which lay the Land of Darkness, i.e., Moor-
ish), attended by a painter (alias Apelles) who made portraits
of all rulers. Candace is visited by Alexander in disguise. "It

is said that Alexander married Candace and stayed there for three nights, and that he lay with her. This is not true." [4] But the disguised Alexander is given great gifts from the king of Egypt to take to the real Alexander. In the Land of Darkness Alexander looks for the Water of Life, without success, and reaches the limit whither the sun sets, mentioned in the "glorious Koran." [5] Then it is a matter of meeting giant scorpions and fish, eventually destroying a city ruled by a deputy of the emperor of China, and Turkestan.

When he reaches China, its emperor tries to murder him, and the account continues to include much that is shared with a Jewish tradition. So he hears a story about an old man who came to Solomon wishing to be able to understand the speech of animals. After a day of enjoying this skill, he decided he wanted no more of it. In Fairyland he meets the Fairy queen, Araqit, who attacks him. On the battlefield he cries out, "Allah Akbar," at which the 100,000 infidel fairies flew away leaving only the Muslim fairies. Araqit fights on and abducts him from his concubine's couch, but he escapes and attacks again, with elephants. The epic of attack and counterattack goes on—one cannot help feeling that the identity of fairies owed something to western observation of the hairless faces of many easterners, notably the Chinese, plus some knowledge of real Asian women warriors, Amazons. Eventually Alexander defeats Araqit, and, unsurprisingly, marries her and departs with treasures.

[4] For Candace, see also Stoneman, *Life*, 134–136.
[5] On the Water of Life in Islamic and Indian stories, see A. Szalc, "In Search of Water of Life: The Alexander Romance and Indian Mythology," in Stoneman et al. 2012, 327–338.

Next, Alexander moves towards "the Russians" but he is troubled by an interesting dream: "about a statue. Its head was made of gold, its chest of silver, its thighs of brass, its legs of iron, and its feet of baked clay. Then a rock fell on the statue, breaking it to pieces and I heard a voice from the statue, saying, 'O son of Nahid [Porus' daughter], this is your temporal career and your kingship', but an angel encouraged him: 'Fear not and take heart, for the faith still remains.'" Daniel had explained it: "The head of the statue made of gold, is your rule which shall exceed the rule of those who will come after you. Its thighs, made of brass, represent those kings who are inferior to you. Its legs, made of iron, represent the Messiah, whose creed is above all creeds in strength, just as iron is above all things in solidity. And the feet, made of baked clay, represent the world, which shall at last end in destruction."[6]

The excursion to the land of the Russians also led him to the land of the Zangi, where he encounters a beautiful zebra, a black snake, and a casket containing yet another beautiful maiden, bound, daughter of the king of the Paradise of the Ganges—so, at least for the benefit of the tale, we are back in India, where the maiden's father arrives with elephants, and Alexander, of course, marries the princess. He confronts the Zangi king, Qatil, who covets his bride and is slain, and Shahmalik, king of all the east. Araqit, the fairy queen, meanwhile gives birth to a son, Iskanderus. Now Alexander and Shahmalik are at odds, and the story disintegrates into a series of battles with Shahmalik; Shahmalik seduces Araqit who goes on to defeat the Zangis, while Alexander defeats

[6] *Daniel* ch. 2.31–45, interpreting Nebuchadnezzar's dream.

Shahmalik, whose brother then captures him, but he is rescued by Araqit. Her cousin Yaqutmalik, a heathen woman, enters the story with a great army; she naturally falls for Alexander, parades her army to impress him, but he surrounds it and Araqit supports him. The activity of so many woman warriors clearly reflects ancient views on Amazons in the east, a very long-lasting tradition and based on fact.[7]

The whole rambling and often self-contradictory tale owes but little to the Romances of the west; it seems rather to assemble a variety of stories appropriate to Asia and India, not otherwise attached to Alexander—except that anything happening there might be. It is a form of Persian Pseudo-Callisthenes. The other Persian story, the *Shahnameh*, by Firdowsi, is only slightly more coherent.[8] His compilation is of the tenth/eleventh century AD while the *Iskander-nameh* was a compilation over a long period of time. Firdowsi is "anti-Arab but not anti-Islam" (D. Davis). His is an epic story of the kings of Persia, and Alexander (Sekandar) appears relatively late in it.

Darab, the son of Ardashir and Homay, is raised by a fuller, but is revealed as a great warrior in battles with Rum and recognised as a royal prince. He marries a princess who bears him Sekandar. He (=Alexander) succeeds to the throne of Rum (roughly, the eastern Byzantine Roman Empire) and associates with the wise man Arestatalis (Aristotle). He attacks Egypt, then marches on Estakhr (Persepo-

[7] Very thoroughly explored by Adrienne Mayor, *The Amazons: Lives and Legends of Warrior Women* (Princeton: Princeton University Press, 2014). And see Stoneman, *Life*, 128–134.

[8] I use *Shahnameh: The Epic of the Kings* (trans. R. Levy, revised by A. Banani, Teheran: Yassavoli, 2009).

lis) and Dara (son of Darab), whom he visits in disguise. He is recognised but manages to escape. He attacks Dara, who is assassinated by the two men who had recognised Sekandar. He comforts the dying king—so far very much in the "true" tradition of Alexander's respect for Darius which was understandably cherished by the Persians. Thereafter the narrative ranges into an account of a different aspect of the common Persian borrowing of western storytelling— Sohrab and Rustam, and so on—a world beloved by the west, notably Matthew Arnold.

It was, however, a Persian account of Alexander that permeated the western regions of the Ottoman Empire, and so became the basis for their Alexander story as told in Old Serbia and Greece. For Old Serbia there is an account of *The Greek Phyllada and the Old Serbian Alexander Romance* by Krzysztof Usakiewicz,[9] and Richard Stoneman has published a translation of the Greek *Phyllada*, which I use here.[10] It lacks nothing in imaginative reconstruction or reworking of history and historical figures, as well as some lively adjustment of the storytelling.

The Egyptian king and wizard Nectanebo figures strongly here.[11] He goes to Macedonia and fathers Alexander on Olympias, appearing to her as horned Zeus Ammon, then as a monster, but with her husband Philip's approval. He shares the education of Alexander with Aristotle. Alexander

[9] In *Colloquia Humanistica* 2 (2012).
[10] *The Book of Alexander the Great* (2012). And cf. D. Holton, *Tale of Alexander: The Rhymed Version* (Athens, 1974, 2002).
[11] K. Ryholt, "Imitatio Alexandri in Egyptian Literary Tradition," in *The Romance between Greece and East* (eds., T. Whitmarsh, S. Thomson; Cambridge: Cambridge University Press, 2013), for the story, see the *Imitatio Alexandri* and the *Dream of Nectanebo*.

acquires the horse Bucephalus but then, as a Greek should, goes to the Olympic Games, with no little success. Back home he repels an invasion by the Koumanoi[12] and joins his "father" Philip in repelling a certain Anaxarchus from Pelagonia (north Macedonia), and Philip dies. Alexander, now king, is persuaded by the Elders that he should assemble a great army and invade his neighbours. In this version Alexander is denied Persian royal ancestry.

Darius mocks Alexander, who prepares to invade Persia, but first marches past Thessalonike (Salonica) and on to Athens, where the philosopher Diogenes from his tub urges the citizens to accept him. They will not, and Alexander defeats them at Castalia (Delphi)—an odd mixture of Philip's real defeat of the Greeks and Alexander's real visit to Delphi. He then turns against the Romans, who send an embassy carrying as gifts the treasure of Solomon, looted by Nebuchadnezzar. He marches on Rome, wearing the crown of Cleopatra. Anachronism is rife here in the attempt to include Roman events. An oracle promises him that he will be king of the world, and he sets off leaving Talamedos as king of Rome.

He sets off south to meet beasts with human faces and an army of winged women. Thence (how?) to England, where he orders a war fleet of 12,000 vessels; and to "Europe," where his general Byzas founds Constantinople (Byzantium; to be the Ottoman capital) and to Egypt to build Alexandria. He visits Troy, where he is given Hector's shield, and then goes home to prepare his horn-helmeted troops

[12] The "Cumans" were an east Asian, Turkic people who travelled west into the upper Balkans and Hungary in the eleventh century and joined the Golden Horde in attacks on Byzantium.

for their eastern adventure. Darius sends Alexander a threatening letter to which he responds in kind. Alexander is welcomed in Jerusalem by Jeremiah. He is properly respectful and receives Goliath's sword, Samson's crown and Saul's robe. Alexander, as son of Nectanebo, conquers Egypt. Though greatly outnumbered he confronts Darius beyond the Euphrates, defeats him—of course—and chases him to Babylon.

Darius sends Abyssos off to kill Alexander, but he fails and is sent back to Darius. Alexander is advised by Jeremiah (in a dream) to go to Darius disguised as a noble Persian. He dines with Darius, is recognised, but escapes. (In many ways this Greek version has more of the makings of a plausible historical novel than most Romances.) Darius asks the Indian king Porus for reinforcements, which are sent. They are defeated, and Darius is assaulted by two of his officers and, dying, is come upon by Alexander, who comforts him and installs his body on a fine wagon. Darius' last act is to ask Alexander to marry his daughter Roxandra (=Roxane), which he does. In an out-of-place interlude, he defeats Krises of Lydia (= Croesus, historically defeated centuries before by the Persian Cyrus).[13]

Thereafter Alexander indulges his familiar fantasy adventures in the east. We might notice the giant ants in caves, since there was a different story, known to Herodotus, about ants that mined gold, which was stolen by the Indians.[14] He built a city for dwarfs who were called monkeys, and then there were the less friendly giants, who had killed Sesonchos

[13] For Jeremiah, see also C. Jouanno in Stoneman et al. 2012, 113.
[14] J. Boardman, *The Archaeology of Nostalgia* (London: Thames & Hudson, 2002): 41–42.

(who had erected a massive pillar). Great pillars are a feature of the region, including one commemorating the death of Hercules and of Sevira "rulers of the Greeks in Macedonia," who had preceded him to the east and to the River of Ocean. He goes on into the Land of Darkness, but returns to an encounter with Indian Porus, who was at least a historical figure, but here has fighting lions as well as elephants. Philo and Seleukos now appear—historical figures of importance after Alexander's death. After a bloody battle, Alexander kills Porus in a duel and admires his palace. Next come the Amazons, whom he threatens, but they stand up to him and offer him troops on a yearly basis. He is led by Kondavlouses to a cave which proves to be an entrance to a Greek Underworld, Tartaros, which also housed his father-in-law, Darius. Kondavlouses introduces him to his "mother" Candace, who recognises him despite his disguise. Alexander sets off back to Persia, distracted only by his familiar underwater adventure in which he encountered a massive fish. He has to face a formidable number of fire-breathing dragons and other monsters.[15] He returns to Persia, where he is told of Jeremiah's dream of his imminent death, and he meets Aristotle again, sent by his mother Olympias. He gives a great party, at which he is poisoned. His horse Bucephalus kills the poisoner, then dies, as does Alexander's wife Roxandra. And then Alexander dies, the moral being, "As Solomon said, Vanity of Vanities, all is Vanity."

This convoluted tale was by no means the last Persian essay devised to tell the history of Alexander, and to draw

[15] D. Ogden, "Sekandar, Dragon-Slayer," in Stoneman et al. 2012, 277–294; these inspire other, local varieties of worm-like monsters to be overcome, such as the Worm of Haftvad, ibid., 285.

the right moral from it. It is fitting in a way that its origin was Persian and transmitted in Greek. Not the least interest in the Persian stories and their kin are the sidelights they offer on views about the geography of the area, and beyond.[16] The fifteenth-century author Jami offers a *Logic of Alexander* which has him chair a conference of philosophers, from Socrates on, plus a god or two; a sort of summing up of achievements.[17]

[16] M. Casari, "The King Explorer: A Cosmographic Approach to the Persian Alexander," in Stoneman et al. 2012, 175–203.

[17] Stoneman, *Life* 38–39; ibid., 41–44, for Persian tales of him destroying Zoroastrian sacred books to promote the true Allah—wry, since Zoroaster was at the root of all eastern religions.

VI

The Indian Alexander

We have had repeated occasions already to consider stories, mainly fictional, about Alexander's adventures in India, where his real history is not too easy to discover although it is substantial, and he had, historically, a profound effect on India's future, which for the most part the Indians did not forget.[1] It is interesting to observe how readily eastern kingdoms seem to have relished association with Alexander, despite the historical record of what he did to their ancestors. What he left behind had become crucial to the development of their own civilisation.

In India there is no real reflection of him in the arts of Gandara in the early centuries AD, where memory of classical Indo-Greek and Parthianizied forms and subjects remained strong though far divorced from their sources.[2] But Philostratus, in the second/third century AD, wrote of the travels of Apollonius of Tyana and how he saw pictures of Alexander's exploits in the Greek temple at Taxila, a

[1] Several relevant studies in Prabha Ray/Potts, *Memory*. Also F. L. Holt, "Alexander the Great, India, and the Mediterranean World," *Indian Historical Review* 32.1 (2005): 288–297.
[2] See Boardman, *The Greeks in Asia* (London: Thames & Hudson, 2015), 167–194. A.J.L. Blanshard, "Alexander the Great and the Myth of India," in Prabha Ray/Potts, *Memory*, 28–39.

major Greek/Buddhist site.[3] In the Greek *Periplus Maris Erythraei*, which described the "new" route to the east via the Red Sea and past South Arabia, the presence of Greek-inscribed coins in Barygaza (some 100 miles north of Bombay) is remarked. Such Greek presence was in itself testimony to the much earlier passage of Alexander's army, and its followers, to the north, and Alexander remained a name and legend on many graecised coins of the region. Greek script too contributed to the formation of the *kharoshti* script in India—all such diffusion of Greekness was the direct result of Alexander leading Greeks so far south. All this activity considerably stimulated trade west-east, well demonstrated by the cache excavated by the French at Begram, near Kabul, which included a mass of Mediterranean goods, Greek and Roman, as well as a bronze equestrian in armor looking much like our man.[4] It is hardly surprising that for some the Nile and the Indus were connected.

Persian and Arab adoption of Iskander/Alexander had its effect far to the east and, naturally enough, into Mughal India. There has been some doubt about whether in Indian languages "Skanda" refers to him.[5] He was born to defeat Taraka (i.e., Darius in Sanskrit), who threatened the peace of the world. Deva Sana, whom he married, is probably

[3] See Boardman, *The Greeks in Asia*, (London: Thames & Hudson, 2015), 138–142.

[4] See Prabha Ray, "Alexander's Campaign (327–326 BC): A Chronological Marker in the Archaeology of India," in *Memory* 112–116; Boardman, *The Greeks in Asia* (London: Thames & Hudson, 2015), ch. 6.

[5] Answered in N. Gupta Pillai, "'Skanda': The Alexander Romance in India" (*All-India Or. Conference* IX, 1937, 955–997; also available at http://murugan.org/research/gopalapillai).

Roxane. Chandra Gupta, the Mauryan emperor of India, faced by Alexander, was said to have worshipped him. And the Greek god Dionysus/Bacchus, carried east by Alexander if not by earlier Greeks, was also thought to have brought wine to the Indians,[6] and himself to have come from the east, where there were festivals of wine which seem peculiarly Dionysiac/Bacchic. In the fifth century AD, Nonnus penned the *Dionysiaka*, a fifteen-book verse epic in which the god challenges all the Olympians and reaches its climax in an Indian War.[7] In the Pamir ranges wild horses are said to descend from Bucephalus—perhaps some recollection of the fiery Ferghana horses ("divine horses that sweated blood") sought by the Chinese in the second century BC.[8] When Alexander eventually turned for home, it was said that he built twelve altars and statues to the Greek gods, as high and broad as the tallest towers. A location for the altars has even been suggested.[9] The statues have been thought to have inspired the realism in Chinese art apparent not so much in the great "Terracotta Army" but in very realistically modelled nude figures recently found.[10] Realism can be attempted anywhere, any time, but there is clear

[6] J. Boardman, *The Triumph of Dionysos* (Oxford: Archaeopress, 2014), ch. 3.
[7] *Nonnos Dionysiaca* (Loeb, 1984; trans. W.H.D. Rouse).
[8] J. Boardman, *Ancient West and East* 2 (2004), 357–358; and in *Afghanistan* (eds., J. Aruz, E.V. Fino, New York, Metr. Mus. 2012), 110ff. And see below, p. 150.
[9] W. Hoey, "Alexander's Altars," *Journal of the Royal Asiatic Society* 38.4 (1906): 1000–1001. Diodorus 17.95. The altars were deemed to rival those of Hercules and Dionysus—Strabo C171 (3.5.5)
[10] J. Boardman, *The Greeks in Asia* (London: Thames & Hudson, 2015), 120.

evidence now that some more complicated western art practices—hollow-cast moulding, etc.—were learned by China from the west, from sources that owed their establishment and continued industry in Central Asia to Alexander's conquests. His force of arms was an unwitting contributor to the diffusion of arts and sciences. But the remarkable Chinese road-building was more in the Achaemenid Persian tradition than the Greek.

Apart from the real legacy of his conquests, Alexander was also easily inserted into Indian history by some writers without much regard to any evidence or even tradition. The sixteenth-century AD traveller Corsali could promote, in Thevet's near-contemporary *History*, the idea that Alexander built the great site and statues of Elephanta.[11] In the eighteenth century, Anquetil-Duperron was told by the Brahmins that the cave temples at Yogeswari, Mandapeswar, and Kanheri near Bombay were built by Alexander.[12]

Kashmir was islamicised, and the sultan of Delhi who died in 1517 was called Sikander Lodi. There was a town Sikanderpur in Uttar Pradesh. Add to this the thought that the alleged descendants of Alexander, fair-skinned, fair-haired, blue-eyed, still lived in Nuristan (see below), and we have the perfect setting for Rudyard Kipling's remarkable short story, "The Man Who Would Be King," printed first in India (1889) and a year later in Britain. In it a British soldier decides to become a king and with his companion (the story-teller, speaking to a journalist Kipling) goes

[11] P. Mitter, *Much Maligned Monsters* (Oxford: Oxford University Press, 1977), 37.
[12] Ibid., 106–108.

north with rifles and teaches military disciplines to villagers. He reminds them that they are the sons of Alexander by Semiramis, not black Mohammedans, persuades them that he is a king (Sikander II), divine and Grand-Master of all Freemasonry in Kafiristan. But when his reluctant consort-to-be named Roxanne (of course) bites his cheek, and blood flows, he is revealed as no more than human, and killed. The splendid film version of 1975, with Sean Connery and Michael Caine, elaborates the original version by having his capital city called Sikandergul, himself as Sikander, and the city a wild confection of ancient Greek structures, from Athens to Knossos.[13] He regards his subjects as "English." It is hardly surprising that another modern fantasy can even attempt to imagine a contest between Alexander and Genghis Khan.

It was inevitable that the British conquest of India and creation of such a massive addition to her empire should invite comparison with Alexander, much encouraged by rich local legend about kinship to Alexander and the Greeks by local tribes and leaders, and indeed the blue-eyed, fair-haired appearance of the Kalash (in the Chitral valley of Pakistan), a trait often observed and similarly interpreted by earlier travellers.[14] India was the first producer of rice, so we need not dwell on the claim that it was Alexander who introduced it (pilaf=plov) to Samarkand.[15]

[13] The presence of Iskander place names in Central Asia has been noticed by many. There is even an Iskandariyah far to the west, twenty-six miles south of Baghdad.
[14] See especially W. Ball, "Some Talk of Alexander: Myth and Politics in the North-West Frontier of British India," in Stoneman et al. 2012, 121–152.
[15] C. Eden and E. Ford, *Samarkand* (London: Kyle Books, 2016), 115.

The Eastern Pictures of Alexander

It is remarkable that so many of the most colourful and orig-
inal pictures of Alexander hail from the arts of his once-
enemies, the Persians, but we have seen how readily they
could take him to their hearts and even make a Persian of
him. The realism of much Persian painting verges on the
classical even more than did that of the Sasanians (who
mainly ignored him) and must owe something to an at least
semiclassical tradition in the east.[16] There is a tendency to
prefer pictures that fill the field though there are several
with more of a landscape effect. They are intensely colourful
and commonly inscribed, indeed many are simply imbed-
ded in manuscript accounts of Persian history, which natu-
rally include Alexander/Iskander, or which dwell on epi-
sodes made familiar through the Alexander stories. Thus,
the killing of Darius figures in one of the earliest manu-
scripts of Firdowsi's *Shahnameh*, the Shiraz MS now in St.
Petersburg, written in 1333. It shows the killing alone with
no watching Alexander.[17] On another in the same MS Al-
exander is seen on horseback watching the wall being built
against Gog and Magog (Juj and Majuj).[18] The Persian
styles of painting and Alexander subjects persist into Mu-
ghal India. A selection of Persian images of the Alexander
story is presented here in plates 9–12.

[16] A good brief account of the Persian pictures is N. Akhtar, "Visual Repre-
sentations of Alexander in Persian Manuscripts," in *Memory*, ch.6.
[17] A. T. Alamova and L. T. Gyosalyan, *Miniatori Rukopisi Poemi "Shah-
name" 1333 Goda* (Leningrad, 1985), no. 37.
[18] Ibid., no. 38.

VII

The Alexander Story in the Renaissance and Down to the Present Day

W e leave the texts of the Mediaeval Romances now, although they remain the principal sources for the tradition picked up in details by later authors and artists, the earliest of them working in years when some Romances were still being stitched together.[1]

Latest Mediaeval and Renaissance England

Mediaeval England had enjoyed its own versions of the Romance, and Chaucer (late fourteenth century) was especially taken by our man:[2]

> The storie of Alisaundre is so commune
> That every wight that hath discrecioun
> Hath herd somewhat or al of his fortune.
> This wyde world, as in conclusioun,

[1] There is a Canadian dissertation by Allison Fisher "Artistic Interest in the Life of Alexander the Great during the Italian Renaissance" (Queen's University, 2013).
[2] D. Ashurst, "Alexander Literature in English and Scots," in Zuwiyya, *Companion*, 289–290.

He wan by strengthe, or for his hye renoun
They weren glad for pees unto hym sende.
The pride of man and beest he leyde adoun
Wherso he cam, unto the worldes ende.

("The Monk's Tale" 743–750)

... and he continues about his life and death:

Who shal me yeven teeris to compleyne
The deeth of gentillesse and of franchise,
That al the world weelded in his deemeyne.
And yet hym thought it myghte nat suffise,
So ful was his corage of heigh emprise.
Alas, who shal me helpe to endite
False Fortune, and poison to despise,
The whiche two of al this wo I wyte?

(Ibid., 775–782)

Chaucer knows of Alexander's flight with four griffins, as a paradigm for high-flying, and continues:

Quod he, for half so high as this
was Alexander Macedo;
as the king, dan Scipio
That saw in dreme,
Helle and earth on pardys;
and higher than Daedalus.

But his military success was more notable:

Alexander the great heard just this sentence
That because a tyrant has great might
By form of armies to slay outright,

And burn house and town and scorch the plain,
Lo he's a mighty general, some explain.

<div align="right">("Manciple's Tale" 294–298)</div>

Sir Gilbert Haye wrote a *Buik of Alexander*, a pentameter poem (1499) translated from the French,[3] but English Renaissance writers did not need to rely wholly on continental Romance sources, and we have already remarked (above, p. 63) on Lyly's treatment of the Campaspe story. In his play *Faustus,* Marlowe (late sixteenth century) borrows a German story and has Faustus summon up a spirit in the shape of Alexander for the Emperor Charles V. He appears before them as "a well-proportioned, stout little man with a red or red-blood thick beard, ruddy already and a countenance as austere as had he the eyes of the Basilisk." "Have I not made blind Homer sing to me/Of Alexander's love" (Act IV, scene 1). And Faustus mounts a play acted by spirits about Alexander killing Darius and winning his paramour. While in *The Jew of Malta*:

As fatal be it to her as the draught
Of which great Alexander drunk, and died.

In Marlowe's *Tamburlaine* Part 2 his hero rides into Babylon comparing himself with Alexander.

Henry Howard, Earl of Surrey (1515–1547) wrote of: .

The great Macedon that out of Perse chasyd
Darius, of whose huge power all Asy rang,
In the rich arke if Homers rymes he placyd,
Who fayned gestes of hethen prynces sang,

[3] Stoneman, *Life*, 168, 243.

... evoking the tale of Darius' chest, taken by Alexander at Issus and used by him to house his copy of Homer.

Shakespeare (late sixteenth / early seventeenth century) was well versed in the classics, and in some detail to judge from his references to our subject. The great soldier and ruler is obviously at the forefront, in verses which every English schoolchild has by heart (or used to have):

> ... fathers that, like so many Alexanders,
> Have in these parts from morn to even fought,
> And sheathed their swords for lack of argument
> *(Henry V*, Act III, scene 1, 19–21)

> He sits in his state as a thing made for Alexander. What he bids is done, is finished with his bidding.
> *(Coriolanus*, Act IV, 20–21)

Even Fluellen can have views about Macedonian geography:

> In Macedon Alexander was born. (Monmouth is compared with Macedon). There is a river in Macedon, and there is also moreover a river at Monmouth—and there is salmon in both.
> *(Henry V*, Act IV, scene 7)

But he is most thoughtful when Hamlet looks at Yorick's body as he might at Alexander's:

> ... as thus: Alexander died, Alexander was buried, Alexander returneth into dust; the dust is earth, of earth we make loam, and why, of that loam, whereto he was converted, might they not stop a beer barrel.
> *(Hamlet*, Act V, scene I, 229–234)

He also knows Darius:

> A statelier pyramis to her [Joan of Arc] I'll rear
> Than Rhodope's or Memphis ever saw,
> Her ashes, in an urn more precious
> Than the rich-jewell'd coffer of Darius
>> (*Henry VI*, part I, Act I, scene 6, 21–25)

Ben Jonson, Shakespeare's contemporary, was better acquainted with his weaker side: "with that voluptuous, rash, Giddy and drunken Macedon";[4] and Marvell with his odours; "Where every Mowers wholesome Heat Smells like an Alexander's sweat".[5]

Milton simply alludes to him:

> The schools of ancient sages—his who bred
> Great Alexander to subdue the world.
>> (*Paradise Lost*, IV 251–253)

> the son of Macedonian Philip had ere these
> Won Asia, and the throne of Cyrus bold
> At his dispose.
>> (Ibid., III 82–87)

> Hath all of desolation, save the peace.
> He "wept for worlds to conquer!" he who ne'er
> Conceived the globe, he panted not to spare!
> With even the busy Northern Isle unknown,
> Which holds his urn, and never knew his throne
>> [reference to an obscure story that he was buried in England].

[4] *Sejanus*, Act I, sc. 2.
[5] *Upon Appleton House*, l. 54.

and

> I am Diogenes, though Russ and Hun
> Stand between mine and many a myriad's sun;
> But were I not Diogenes, I'd wander
> Rather a worm than such an Alexander!
> Be slaves who will, the cynic shall be free;
> His tub hath tougher walls than Sinope.

The European Renaissance

Renaissance scholars as well as artists were taken with Alexander, and were not altogether dependent on the Romances. The thirteenth-century Catholic saint Albertus Magnus somehow knew of Alexander's discovery of the *caladrius*, a white bird that could foretell the future and whether the sick would survive. In the mid-fifteenth century the Portuguese Vasco da Lucena translated (into French) Quintus Curtius' *Deeds of Alexander*.[6]

Dante found a place for Alexander in his *Inferno*, Seventh Circle (Canto XII 103) but did not dwell on him. But he does refer to an episode in India where Alexander saw flames falling onto his troops (*Inferno* Canto XIV, 31–36). Boccaccio often alludes to him, and Domenico Falugio wrote a more historical *Triompho Magno*.[7] In art, the episode with Diogenes is more often remembered. It figures on some majolica—a plate by Manara Baldissaro of the 1530s, in the Ashmolean Museum, plates in Lyon and by Giulio da

[6] MS in the Getty Museum: Ms. Ludwig XV 8.
[7] R. Morosini, "The Alexander Romance in Italy," in Zuwiyya, *Companion*, 357–360, 363–364.

Urbino in the Holburne Museum, Bath. But we look to painting for the masterpieces, and here we find many European painters much taken by the Alexander theme, and not altogether deriving their subjects from the Romances.

The Renaissance artists were affected by both the discovery of true (or at least Romanised) classical art and an interest in ancient history and texts. They had behind them, as we have seen, a rich tradition of mediaeval illustration of Alexander, but they had their own preferences, for artistic or sometimes political purposes, and some episodes proved to be especially favoured. This includes attempts to depict whole stories as a sequence of scenes as well as in the well-known episodes. A good early example is the tempera on wood painting by Domenico Ghirlandaio and others (Siena, 1452–1525),[8] probably intended for the backboard of a bed, and inspired by Plutarch's account of Alexander's life rather than by earlier art (fig. 21). It offers a panorama of scenes starting at the right with a cavalry battle. Then, at the centre, Darius' tent filled with the gold and jewellery now claimed by Alexander, and at the left the pavilion housing a great banquet to which Darius' womenfolk, shown in the background, were invited. Thus we have a typical early Renaissance narrative painting that depicts the separate episodes of one story side by side.

It is interesting to observe which episodes most attracted the Renaissance artists. Two tapestries woven in Burgundy about 1460 were given by Charles V to Andrea Doria for his Genoa palace. One was devoted to Alexander's youthful ad-

[8] Victoria and Albert Museum, E.373–2006.

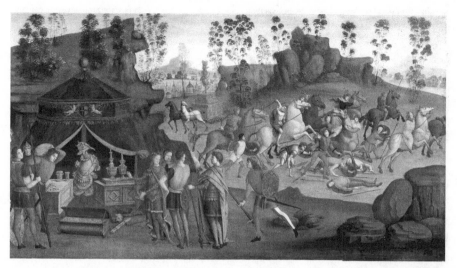

FIGURE 21. Ghirlandaio, painting on wood. Alexander with Darius' family. Victoria and Albert Museum E 373-2006, London. © Victoria and Albert Museum, London.

ventures, the other to the eastern campaigns. Another group has subjects chosen for one locality: the sixteenth-century decoration of the Villa Farnesina in Rome. This offers a good selection of the most popular: the taming of Bucephalus, Alexander meeting his new bride-to-be Roxane (fig. 22), the Darius family before Alexander. The last two mentioned were by Sodoma (1477–1549). The family before Alexander is an interesting choice since the centrepiece is of Darius' mother mistaking Hephaistion for Alexander, with the former gesticulating towards his superior who modestly does not complain of her mistake. The same theme is taken up dramatically in a large painting by Veronese (1528–1588) in 1567 made for Francesco Pisani and seen by Goethe in the Palazzo Pisani Moretta in Venice, and bought by the

FIGURE 22. Alexander meets Roxane. Fresco by Sodoma (1516/1517). Villa Farnesina, Rome. AKG-images / Andrea Jemolo.

National Gallery in London, after some dispute over the price, in 1860 (fig. 23). A far more unusual subject, Alexander being shown the Sacred Book in Jerusalem, was the subject of a painting in Madrid by Sebastiano Conca (1680–1764). Tiepolo offers Alexander and Bucephalus (1760),[9] and Lengetti a very intimate Diogenes (1650).[10] Pope Paul III (Alessandro Farnese, 1468–1549) issued several coins and medallions featuring his namesake, and one with him before the High Priest at Jerusalem (fig. 24).[11]

[9] Rapelli, *Symbols*, 72.
[10] Ibid., 76.
[11] Saunders, *Tomb*, fig. 9.

FIGURE 23. Paolo Veronese, The Family of Darius before Alexander (1567). National Gallery 294, London. © The National Gallery, London.

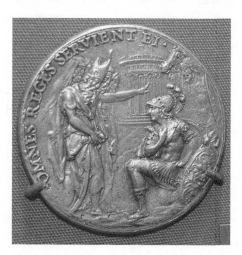

FIGURE 24. Medallion of Pope Paul III. Alexander before the High Priest at Jerusalem. © Nicholas J. Saunders.

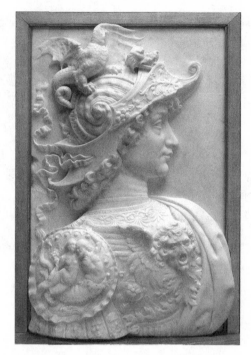

FIGURE 25. Marble helmeted head of Alexander by A. Verrocchio, 1483/1485. National Gallery of Art 1956.24, Washington, DC.

Verrocchio made a much copied portrait head of him wearing an elaborate helmet, the crown as a Medusa mask, in the 1480s (fig. 25). This portrait type with the ornate helmet long remained a popular subject for artists, with various identities for the wearer, or none, and especially for the decoration of gems and cameos. Much later (1626/1627) Giulio Romano painted him standing holding a statuette of Victory, for the Gonzaga family of Milan. Alexander did not have a real and spectacular Apotheosis to take his place with the Gods in antiquity although he might have expected one. The Italian Mitelli and Colonna created one (1636–1641)

FIGURE 26. Apotheosis of Alexander by Mitelli and Colonna. Pitti Palace (Silver Museum), Florence. © The Granger Collection Ltd.

for the ceiling of the Pitti Palace in Florence:[12] Alexander is swept to heaven over clouds, in a chariot, being crowned by two Graces (or the like) attended by two Cupids and a woman trumpeting, her instrument proclaiming "Fortunam Alexandri mirare, imitare Virtutem" (wonder at Alexander's fortune, emulate his virtue) (fig. 26). It was not all Italy. The Spanish Matias de Torres (1635–1711) drew an Alexander with a globe, now in the Courtauld Institute.

[12] Ibid., 78–79.

Seventeenth- to Eighteenth-Century France and Britain

France was well provided with French Romances of Alexander, in prose and verse, but, while elements of them survived in literature and the arts, in many respects it was the (apparently) historical Alexander that attracted attention. Even in the sixteenth century Montaigne could find occasion to refer to his foppishness and sweet-smelling body. It was a French Romance in verse that introduced the "Alexandrine" line (one of Alexander's less fortunate contributions to literature):

> The needless Alexandrine ends the song;
> That like a wounded snake drags its slow
> length along—

was Alexander Pope's famous comment on the twelve-syllable line.

In the mid-seventeenth century Eustache le Sueur (1617–1655) had painted an "Alexander and his Doctor," choosing an unusual episode to record. The sick Alexander is seen drinking a potion despite the report that his doctor had been corrupted by the Persians. It was a signal display of loyalty to his friend, the doctor Philip, and the scene and figures are composed most sympathetically (fig. 27).[13] Alexander with his doctor remains a popular theme with its semiscientific connotations.

However, in French treatment of Alexander, the real hero is Louis XIV, the Sun King, who, in 1661 summoned to Fon-

[13] In the National Gallery, London. Followed in the nineteenth century by a version by the Polish artist Henryk Siemiradzki.

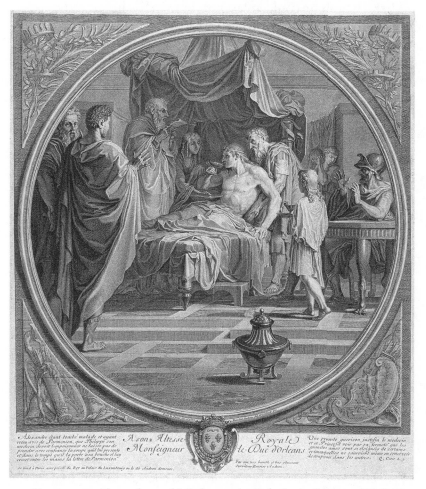

FIGURE 27. Alexander and his doctor, by E. le Sueur. National Gallery, London. Image credit: Wellcome Collection (CC BY 4.0).

tainebleau the artist Charles le Brun and "asked him to paint a subject of his own choosing, provided only that it be drawn from the history of Alexander."[14] Alexander was his

[14] D. Posner, "Charles Lebrun's *Triumphs of Alexander*," *The Art Bulletin* 41.3 (1959): 237–248 (239 quoted here).

hero, whom he could at least try to match—he danced him
in a ballet, but his intentions were more serious, to place his
own and Alexander's achievements on a par. The king had
decided to govern France personally (after his chancellor
Mazarin's death) and was staking his claim to an heroic
reign. He watched the artist's work daily. The first subject
was The Tent of Darius, which may seem an odd choice, but
we have found it already in Renaissance art, and it seems to
have preoccupied some French writers also:[15] "une des plus
Glorieuses qu'ALEXANDRE ait jamais Faites" (one of the
most glorious that Alexander ever made). Le Brun's tech-
nique was to make large etchings of his subjects, sometimes
oil paintings, but the etchings were to be the source for se-
ries of massive tapestries to adorn palace walls. He pro-
posed other subjects: Alexander pardoning Timokles, ex-
pelling the wife of Spitamenes, cutting the Gordian knot,
but it seems that these relate to a series of paintings made in
Rome about 1612 for Cardinal Alessandro (note the name)
Peretti. Racine's play *Alexandre le Grand* appeared in 1665,
dealing with Alexander's courteous treatment of Porus and
his love for an Indian princess Cleophile; it was translated
into Greek.

Desportes later wrote "Alexandre le grand avoit eu le
bonheur *de posséder un Apelle; on peut dire que Louis le
Grand* méritoit d'avoir un le Brun' (Alexander the Great
had the good fortune to have an Apelles; it could be said

[15] Ibid., 240–241, n. 24. The real tent of Alexander, used for councils of war
and marriage, copied the Persian practice; see L. Llewellyn-Jones, *King and
Court in Ancient Persia 559–331 BCE* (Edinburgh: Edinburgh University
Press, 2014), 181–182.

that Louis the Great deserved a le Brun).[16] Louis' successes in Europe may have entitled him to regard himself as a new Alexander, but he was to be eclipsed, beaten on the field of battle by a newer Alexander, John Churchill, soon to be made first duke of Marlborough. He was celebrated in his newly built Blenheim Palace in Oxfordshire, named for one of his victories over the French. Marlborough outdid Louis by commissioning eight (later twelve) tapestries of le Brun's Alexander series in 1707 from Flemish weavers,[17] and some of them still adorn the Private Apartment walls and stairs at Blenheim Palace (plates 13–16). A "Gentleman of Oxford" took note of some of them in 1800 in *The New Oxford Guide*, listing:

Apartment A: Alexander at Darius' tent; with the Magi and Diogenes (in his tub)
Apartment B: The Battle of Arbela (=Gaugamela); the defeat of Porus
Apartment C: The passage of the Granicus river; the entry into Babylon

[16] Ibid., 245. His Entry into Babylon also appears on a French fan of the period (Victoria & Albert Museum).
[17] They are not much regarded in le Brun studies (e.g., Posner) but are well documented and several illustrated in J. Bapasola, *The Tapestries at Blenheim Palace* (Lightmoor Press, 2005), where there is an excellent account of their history (and a bust of Alexander, p. 42). L. Marchesano and C. Michel, *Printing the Grand Manner* (Los Angeles: Getty, 2010) record a Getty exhibition on the subject with fine illustration. And cf. M. Gareau, *Charles LeBrun: First Painter to Louis XIV* (New York: Abrams, 1992). On le Brun and Alexander, see also the chapter by E. J. Baynham in eds. W. Heckel and L. A. Tritle, eds. *Alexander the Great*, ch. 16. I am indebted to His Grace the Duke of Marlborough for permission to photograph the tapestries; I am his neighbour in Woodstock.

The Blenheim tapestries are enormous, to cover the walls of major apartments of one of the largest and most ambitious new buildings of its day. They were 4.11m high, each to incorporate the new ducal coat of arms, but without any silver or gold, and costing 22 florins per ell. The largest was the Battle, 21 feet wide, then the Granicus and Porus at 20 feet, Babylon at 17.5 feet, and two narrow panels showing prisoners. They were delivered in 1709. Four more tapestries were then ordered from a different maker in the same year and delivered in 1710: Darius' family (the tent), Diogenes, and Alexander dismounted, with his father. Several of the panels had to be trimmed or folded to fit the walls. The Porus battle was, for some unknown reason, transferred to Berkeley Castle.

In the mid-eighteenth century the Venetian baroque painter Fontebasso created Alexander paintings very similar to le Brun's.[18]

Eighteenth- to Nineteenth-Century European Arts and Literature

Later English literature follows the strong Shakespearean tradition of a close knowledge of the classics as retold by recent generations in Europe, therefore as much of the romantic lore as of the history.

In England Dryden was most taken by the festal aspects of the Bacchic Alexander Triumph in his "Feast of Alexan-

[18] P. Briant, *Alexander the Great: The Heroic Ideal* (London: Thames & Hudson, 1996), 2–7 for pictures.

der," which dwells closely on the details of the festive procession without bothering much about Alexander himself. Indeed it becomes more a celebration of the healing effects of music and of St Cecilia's day, a subject of Dryden's that was fit for Handel to set to music: the 1726 opera; and, from "Alexander's Feast," "St Cecilia's Day" (1736). There was also an organ setting by Jeremiah Clarke. J. S. Westmacott was inspired by it to make a statue of Alexander, with hardly any very Alexanderish characteristics, which stands in London's Mansion House.[19] A more original view of him resting, in bronze, in a private collection, was made by E. Herter.

On the continent the story of the Feast was orchestrated by Mozart, who also proposed an opera on Alexander and Roxane for Paris in 1778, but never finished it. The Italian baroque composer Vivaldi composed operas *L'Incoronazione di Dario, La Candace* and *Siroe re di Persia*, between 1717 and 1727. Wagner possessed the German *Alexanderlied* poem and proposed an opera with the death of Cleitus in the first act, the return from India in the second, and his death the third, the libretto drawn from the work of the great historian Theodor Droysen. The flower-maidens of Wagner's *Parsifal* also derive from Alexander's eastern adventures as told in the *Alexanderlied*.[20]

Trivia about Alexander came readily to the poets' minds. Alexander Pope's "Epistle to Dr. Arbuthnot" recalls his stature:

[19] A copy by G. Dance in the Courtauld Institute.
[20] D. Buschinger, "German Alexander Romances," in Stoneman et al. 2012, 310–313.

> I cough enough like Horace, and though lean, am
> short,
> Ammon's great son was one shoulder head too high
> [an allusion to the result of a wound allegedly
> suffered by Alexander to his shoulder at the
> outset of his invasion of India]

But otherwise he had little time for him:

> ... he whose head the lightning forms
> ... turn young Ammon loose to scourge mankind
> <div align="right">(Essay on Man Epistle 4, 220)</div>

> From Macedonia's madman to the Swede [Charles
> XII]
> The whole strange purpose of their lives, to find
> Or make, an enemy of all mankind.
> <div align="right">(Ibid., 233–236)</div>

> The youth that all things but himself subdu'd
> His feet on sceptres and tiaras trod,
> And his horn'd head belong'd the Libyan God.
> <div align="right">("Temple of Fame," 11–13)</div>

Matthew Prior (1664–1722) was taken, as were other writers, by the story of Alexander and the artist Apelles, probably for the accompanying love interest:

> Dear Howard, from the soft assaults of love
> Pets and painters never are secure ...
> To great Apelles when young Ammon brought
> The darling idol of his captive heart
> And the pleased nymph with kind attention sat
> To have her charms recorded by his art

The amorous master own'd her potent eyes
Sigh'd when he look'd, and trembled as he drew;

But our hero was great-hearted . . .

Renowned in bounty as in arms,
With pity saw the ill-concealed distress;
Quitted his title to Campaspe's charms,
And gave the fair one to the friend's embrace

Views on Wellington, victor of Waterloo, were mixed, and
he was not always the Alexander of the modern age. Lord
Byron wrote a poem extolling Napoleon, dismissing Wel-
lington, and using Alexander—*The Age of Bronze* (1823):

Though Alexander's urn a show be grown
On shores he wept to conquer, though unknown—
How vain, how worse than vain, at length appear
The madman's wish, the Macedonian's tear!
He wept for worlds to conquer—half the earth
Knows not his name, or but his death, and birth,
And desolation; while his native Greece
Hath all of desolation, save the peace.
He "wept for worlds to conquer!" he who ne'er
Conceived the globe, he panted not to spare!
With even the busy Northern Isle unknown,
Which holds his urn, and never knew his throne.

And:

I am Diogenes, though Russ and Hun
Stand between mine and many a myriad's sun;
But were I not Diogenes, I'd wander
Rather a worm than such an Alexander!

> Be slaves who will, the cynic shall be free;
> His tub hath tougher walls than Sinope.

Poets remained more aware of the traditional stories, without messages. Robert Browning, writing for the near-blind artist Gerard de Lairesse, conjures up for him a gallery of Alexandrian images:

> Who flames first? Macedonia is it thee?
> Ay, and who fronts thee, King Darius drapes
> His form in the purple fillet-folds his brow . . .

One might have expected that neoclassical architectural sculpture could have embraced Alexander as a subject for the decoration of buildings, but this is not the case except for several later town statues of Alexander on Bucephalus. The truly divine are on the whole preferred, although in France Campaspe (again) disrobing for Apelles' portrait does appear in a niche on the Louvre (about 1883, by Auguste Ottin) (fig. 28), but she is one of many, otherwise fairly obscure heroines displayed there.

Nineteenth-century British arts moved from neoclassicism to the Pre-Raphaelites; and more importantly they became imperial. Empires beget heroes, military ones like Wellington, but also politicians. William Pitt could already be portrayed in a classical statue—a fine example in Charleston, South Carolina. Wellington's victories could claim immortal status with a colossal bronze nude, eventually removed from Hyde Park Corner, and the other colossal iron figure of Achilles also at Hyde Park Corner, while in his home nearby (Apsley House) Canova's marble Napoleon stood as a naked hero, an implausible personification of Peace, and disliked by its owner. Sir Robert Steell was com-

FIGURE 28. Campaspe by A. Ottin, in a niche on the Louvre façade, Paris. © Marie-Lan Nguyen / Wikimedia Commons.

missioned to make a large bronze group of Alexander taming the horse Bucephalus for Edinburgh in 1862 (fig. 29). It was alleged that when money began to run out he deliberately replaced the horse's ears with pig's ears—they are quite small. He used the same group for a statue to Wellington in Princes Street, London. But this was a type for civic settings of long and wide popularity. The classicist British sculptor Richard Cockle Lucas (1800–1883), who spent a lot of time copying the Parthenon and its sculpture, ignores Alexan-

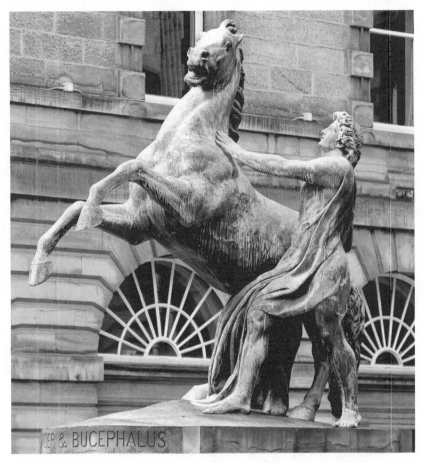

FIGURE 29. Bronze Alexander and his horse, by John Robert Steell, before the City Chambers, Edinburgh. © Stefan Schäfer, Lich / Wikimedia Commons.

der's vivid features and demotes his horn in favour of quietly classical features on an ivory relief (fig. 30).[21]

A notable tribute to Alexander from Napoleon is in fact now in London. Napoleon had commissioned (1806–1812)

[21] Victoria and Albert Museum 205–1865.

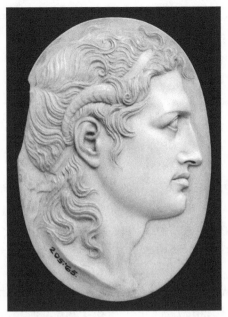

FIGURE 30. Ivory relief of Alexander by R. C. Lucas. Victoria and Albert Museum 205-1865, London. © Victoria and Albert Museum, London.

a large round table with a Sevres porcelain top, depicting the head of Alexander in the centre, and twelve other ancient commanders and philosophers around the edge, signed by L. B. Pavant. Louis XVIII gave the table to George III, and its stands now in the Blue Drawing Room of Buckingham Palace.

French and German artists of the later nineteenth century seem to have been much engaged by Alexander, often in original compositions rather than variations on the old themes.[22] For the French A. Castaigne (1861–1929) has him

[22] Many are illustrated in Chugg, *Lovers*.

bullying the Pythian oracle at Delphi, cutting the Gordian Knot, the punishment of Bessus, the killing of Cleitus, the surrender of Porus, attacking a Mallian town, quelling mutiny, sacrificing at Troy, marrying Roxane.[23] In France, Courtois (1878) offers an unusual scene of Caesar staring at Alexander's body.[24] And there are many Germans—Andreas Muller (1811–1890) has the marriages at Susa; Louis Loeb (1866–1909) the Diogenes episode; Karl von Piloty (1826–1886) his death; F. Schommer (1850–1935) a more traditional rendering of Alexander taming Bucephalus.[25]

In the same tradition, there is a detailed study of Alexander's funeral procession with the elaborate bier in an oil by the "naïve" French painter André Bauchant (1873–1958), which was hung in the Tate Gallery in London (fig. 31); and the French F. Jaffé has the pyre of Hephaistion.[26] There is a particularly well-peopled scene of Thais persuading Alexander to burn Persepolis by the Italian G. Simoni.[27] England did not neglect him by any means. James Sherwood made a marble sculpture of him, for London's Mansion House; and Earle was said to have died of a heart attack because his Alexander was not exhibited at the Royal Academy after he had taken three years to finish it.[28]

We might have expected something from Wedgwood's great collection of models, for anything from a ring stone to

[23] All illustrated by Chugg, ibid.
[24] Rapelli, *Symbols* 77.
[25] Again, all in Chugg, ibid.
[26] Ibid., fig. 3.12.
[27] Ibid., fig. 1.8.
[28] B. Read, *Victorian Sculpture* (Yale: Yale University Press, 1982), 246, fig. 313; 52.

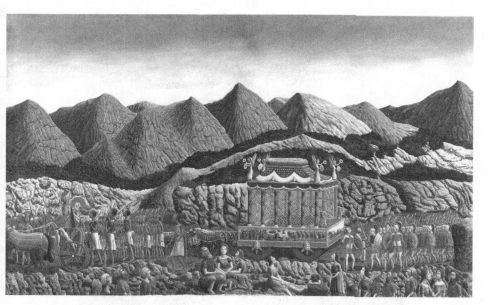

FIGURE 31. The procession with Alexander's bier, by Bauchant. Tate Gallery, London. Image credit: *Les Funérailles d'Alexandre-le-Grand*, 1940, André Bauchant (1873–1958). Bequeathed by Arthur Jeffress 1961. Photo credit: © Tate, London 2018.

an urn, but there are only a few Alexander heads on medallions, a copy from one of Tassie's gem casts, and the like. But there are basalt busts of Alexander in Holkham Hall and Buckingham Palace, said to be "Wedgwood." New York has a Wedgwood (?) medallion of Alexander riding an elephant, and labelled *Alexander Macedo*. The fine classicising gems associated with the name of Prince Poniatowski often turned to Alexander for inspiration: for example, we have him with Diogenes, cutting the Gordian Knot, with his doctor, killing a lion, taming Bucephalus, and heads (fig. 32).[29]

[29] See http://www.beazley.ox.ac.uk/gems/poniatowski/database.asp; database: reference nos. T1180, T1182, T1183, T1184, 1839–717, 1839–719.

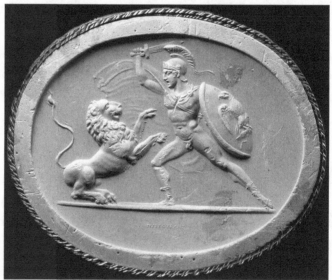

FIGURE 32. Neoclassical gems: a. Alexander and the Gordian knot (image courtesy of the Beazley Archive, Reference Number: 1839-717); b. Alexander killing a lion (image courtesy of the Beazley Archive, Reference Number: T1184). Beazley Archive (Poniatowski Coll.), University of Oxford.

Returning to poetry, we find the poet Swinburne taking a sophisticated approach in his "Song for the Centenary of Walter Savage Landor":

> He that sought of old
> His father Ammon in a stranger's land
> And shrank before the serpentining fold,
> Stood in our seer's wide eye
> No higher than a man most high,
> And lowest in heart when highest in hope
> to hold
> Fast as a scripture furled
> The scroll of all the world
> Seal'd with his signet; now the blind and bold
> First thief of empire, round whose head
> Swarmed carrion flies for bees, on flesh for
> violets fed

Illustrated books become a major source for both story and image in nineteenth-century Britain. They could have a strongly didactic air, whether directed to children or adults. Mrs. Trimmer's *Lessons on Ancient History* is quite uncompromising. She starts Lesson 1 "People, or nations, are divided into *barbarous* and *civilised*. Barbarous nations are those, who lead a savage life: civilised nations are those, who are skilled in arts and sciences." Alexander finds his place, his achievements taking barely a page before he retires to Babylon: "his glory was of short duration; for he had one very great fault, which was that of being fond of feasting and drinking. He wanted to make the world believe, that he was a God, and could do whatever he chose. When he was at a banquet, he would try to drink more wine than any man in

131

Chapter VII

94 ANTIENT HISTORY.

splendor. But his glory was of short duration; for he had one very great fault, which was that of being fond of feasting and drinking. He wanted to make the world believe, that he was a God, and could do whatever he chose. When he was at a banquet, he would try to drink more wine than any man in company.

At length, he engaged to empty a cup, called Hercules' cup, which held six bottles of wine, and it is said he actually did so: but it proved the cause of his death, the wine heating his blood to such a degree, that it brought on a violent fever, which soon put an end to his life. [ÆT. 32. A. C. 323.]

ANTIENT HISTORY. 95

How shocking it is to think, that a man who had subdued so many nations, should suffer himself to be conquered by intemperance!

It is a certain truth, that intemperance kills more than the sword.

The glory of the Grecian empire was terminated by the death of Alex-

FIGURE 33. Drunken Alexander. From Trimmer, *Lessons*.

the company.... How shocking it is to think, that a man who had subdued so many nations, should suffer himself to be conquered by intemperance!" And she illustrates his intemperance (fig. 33).

Robert Steele published in 1894 *The Story of Alexander*. He shows a good command of the historical sources as well as of the Romances which are incorporated historically. Steele was a distinguished mediaevalist (1860–1944), a disciple of William Morris. His book was not written for children but in an opening letter to "Gracie" he expresses much

about the story that could appeal to all ages and reflects the attitude and enthusiasm of many who retold the story over some two millennia. More important in a way are the illustrations to Steele's book, by Fred Mason, presented in a thoroughly Pre-Raphaelite manner, and with no little humor, as in his rendering of 'how Darius the Emperor sent presents to Alexander, and what was the present sent back to him" (fig. 34a) with an exultant Darius mocking the gifts. The illustrations also included Alexander mourning the death of Bucephalus, at the Altar of Willing Victims in the Valley of Terror (fig. 34b) on the way to the Well of Life. His flight was rendered in the mediaeval manner (fig. 34c), but his descent to the depths of the ocean offers some exciting wild life (fig. 34d).

America does not figure much in our story until the advent of film, although in 1865 Alonzo Chappel (1828–1867) engraved a rather tame Surrender of Porus.

Twentieth-Century Britain

James Elroy Flecker took a serious view of stories of the east;[30] witness his splendid play *Hassan* and his "Golden Road to Samarkand." He could pick up stray Greek lore about "Alexander, Alexander, The king of the world was he" in a short poem about a mermaid who loved him.[31] He is more serious in his "Ballad of Iskander":

[30] On Flecker the orientalist, see the lecture by C. E. Bosworth, *Bulletin of the John Rylands Library* 69.2 (1987): 359–378. James Elroy Flecker (5 November 1884–3 January 1915) was the indifferent love object of the famous classical art historian, John Beazley.

[31] *Collected Poems* (ed., J. Squire, London: Secker, 1938), 173f., "Santorin."

a

CHAPTER VIII. TELLS HOW DARIUS
THE EMPEROR SENT PRESENTS TO
ALEXANDER, AND WHAT WAS THE
PRESENT SENT BACK TO HIM.

BUT IT FELL THAT SOME of them
of Tyre had fled into the court of
Darius, and they complained to him of
their city destroyed, and "all this," said
they, "we suffered because we obeyed the
great king, the Emperor Darius." Then began the
Emperor to question them concerning this Alex-
ander, what manner of man he was, what was his
stature and his strength, whether he were brave or
no. And they, willing to bring shame on the name
of their enemy, shewed Darius a painting of him on
parchment. But when Darius looked on it he burst
into laughter, and all men smiled, and he said:
"Well for ye, ye men of Tyre, if ye were beaten by
such a man as this, for never saw I such a warrior,"
63 for

b

c

CHAPTER XIX. TELLS HOW ALEXANDER
DEFEATED GOG AND MAGOG, HOW HE
WENT UP INTO THE AIR, AND DOWN
INTO THE SEA.

CANDOYL and Alexander rode from the
city out into the open country, and all
day passed through it, till as the sun
went down they came near the hills,
and they found there a cave, great
beyond measure, hidden between two hills, and
there they harboured all night. And when evening
was come Candoyl spoke to Alexander and said,
"Sir, in this cave men say that the gods appear,
and tell men what shall come to pass." Then was
Alexander rejoiced and gave thanks to the gods,
and went in to the darkest part of the cave, but
Candoyl abode at the mouth. And as Alexander
drew near he saw a great cloud and from it a light
glimmering like stars, and as he gazed him thought
188 he

d

FIGURE 34. Illustrations from Steele, *The Story of Alexander* (Lon-
don: David Nutt, 1894). a. Exchange of presents. b. The altar of
Willing Victims. c. Alexander's Flight. d. Alexander's descent into
the sea.

134

Sultan Iskander sat him down
On his golden throne, in his golden crown,
And shouted, "Wine and flute-girls three,
And the Captain ho! Of my ships at sea"

He drank his bowl of wine, he kept
The flute girls dancing till they wept,
Praised and kissed their painted lips,
And turned to the Captains of All his ships.

And cried, "Oh Lord of my ships that go
From the Persian Gulf to the Pits of Snow,
Inquire for men unknown to man!"
Said Sultan Iskander of Yoonistan.

And the Captain, ho! Of my ships at sea
"Daroosh is dead, and I am King
Of everywhere and everything:
Yet leagues and leagues away for sure
The lion-hearted dream of war.

"Admiral, I command you sail!
Take your ship of silver mail
And fifty sailors, young and bold,
And stack provisions deep in the hold,
And seek out twenty men that know
All Babel tongues that which flaunt and flow;
And stay! Impress those learned two,
Old Aflatun and Anstu,
And set your prowe south-western ways
A thousand bright and dimpling days
And find me lion-hearted Lords
With breasts to feed our rusting swords.

So the captain set off in his ship "of silver mail" with Plato and Aristotle (Aflatun and Aristu) aboard. For "seven years and seven years" they sailed and found nothing, while their ship grew old and rusty. Then they came across a silver ship, as bright as theirs had once been, whose Lord told them:

> A mile beyond the millionth mile,
> We know not South and we know not North,
> And SULTAN ISKANDER sent us forth.

Then Plato recognised that the ship was a phantom replica of their own ship, which then "crumbled into air."

But Flecker also exploited a Greek island story about a mermaid (Alexander's half-sister Thessalonike) and Alexander, in his "Santorin" (A Legend of the Aegean), introducing a new parentage:

> "And how should I know your lover,
> Lady of the sea?"
> "Alexander, Alexander,
> The king of the World was he."
> "Weep not for him, dear Lady,
> But come aboard my ship.
> So many years ago he died,
> He's as dead as dead can be."
> "O base and brutal sailor
> To lie this lie to me.
> His mother was the foam-foot
> Star-sparkling Aphrodite;
> His father was Adonis
> Who lives away in Lebanon,
> In stony Lebanon, where blooms

His red anemone.
But where is Alexander,
The soldier Alexander,
My golden love of olden days
The king of the world and me?"
She sank into the moonlight,
And the sea was only sea.

Mermaids, often two-tailed, are a feature of Greek folklore rather than romance.

A final toast: there is a Brandy Alexander—*crème de cacao*—brandy and cream.

VIII

Alexander, Star of Film, Stage, and Novel

Alexander seems to have been ignored as a subject for the movies until after the Second World War, but he was soon on the stage, as in Terence Rattigan's *Adventure Story* (1949). A full-length film, *Alexander the Great,* was shot in Spain in 1955, starring Richard Burton (fig. 35) and Claire Bloom. It dwelt more on what happened before he marched east, in the Macedonian court. His tutor Aristotle is prominent, as well as his Persian lover Barsine and her father, and the rebel Greek Memnon. Barsine's Athenian connections are stressed, but they are, not surprisingly, with Demosthenes. In fact the Greek element is strong; "Greece is where you are," says Barsine, and Alexander can call himself "the little Greek boy." On the expedition the battle cry is "kill Darius," and Alexander pursues him after he flees the battlefield, but respects his body after he was killed by his followers. On to Persepolis where Roxane seems to become a daughter of Darius, and Barsine plays a major role in the burning of the city. Alexander affirms his intention to go to the ends of the earth. "He has outshone the gods." In the east he kills his companion Cleitus and makes a hard journey back to Babylon where he promotes marriages between Greeks and easterners and prays for

FIGURE 35. Richard Burton as Alexander (film). AF Archive / Alamy Stock Photo.

peace between peoples. (Nice to have this episode stressed.) He wishes to consign his body to the Euphrates and, as in the ancient tradition, to leave his empire "to the strongest." The décor devised for Macedonia is "Greek" with elements from the Mycenaean to Late Roman. That for Persia is in many ways more plausible, with the Persian soldiers being decked in yellow tunics.

In 1968 a video film on Alexander was narrated by William Shatner (better known from TV and film as the captain of the starship *Enterprise*), and there were other shorts and videos. In 2005 a "Castle Home Video" by Sue Osler was released: "Alexander the Great, Modernising the Classic Legend." It was meant to debunk the Alexander "history" yet dwells much on the supernatural parts of the story, or the improbable and sensational (manhandling the priestess

at Delphi, etc.), rather than the history, and so ignores various aspects of his "true" life that we might well question today, especially his treatment of the Greeks.[1] Marc Mc-Millan made a seven-minute video based on the Alexander of *Daniel*. For the 2002 film of H. G. Wells' *The Time Machine* the hero, not named by Wells, is an Alexander. Senki made a TV series in 1997 based on a novel, *Alexander* by Hiroshi Aramata, of which there was an American version, *Reign* (2003). It covers also his exploits in India and appears to herald his inauguration of a "new world." The Senki TV series made other computer animations about Alexander. A TV *Great Crash Course on History* starts with Alexander and goes on through other generals and aspects of Greatness, via Catherine the Great and even the Kardashians. And there have been several other "shorts" and videos, trivial and unmemorable. Another Japanese animated series, *Fate/Zero* has Alexander as one of the servants in the Holy Grail War. The group Iron Maiden recorded (*Somewhere in Time*) a heavy metal song "Alexander the Great." And there are several other "modern" songs and even computer games that manage to star Alexander.[2]

Another major film of his life appeared in 2004, with various later versions ending (?) with one 206 minutes long in 2013, directed by Oliver Stone, starring Colin Farrell, Anthony Hopkins, and Angelina Jolie (as Olympias). Farrell's

[1] Osler also scripted a 2004 film, *Alexander the Great: Footsteps in the Sand*, spoken by Liam Dale, and notable only for its irrelevant visual material, mispronunciations, and inept portrayal of historical figures. She deduces that he was a "sadistic, brutal, killing machine," to be compared with Hitler, and "the worst example of a misspent youth that the world has ever seen."

[2] See Wikipedia, "Cultural Depictions of Alexander the Great."

Irish accent was criticised by some, but Irish:English as Macedonian:Greek seems a fair translation. The film is in the approved modern manner, interior scenes all shot in the half-dark. The historian Lane Fox's appearance on horseback leading a charge in the film is unfortunately no guarantee of its historical accuracy. It is presented as a series of flashbacks by Ptolemy Soter some forty years after Alexander's death, and seems quite indifferent to the sequence of events. The main early campaigns and the burning of Persepolis are quickly dispensed with so that there is more time to dwell on his private life, with Hephaistion and the latter's jealousy of Roxana. The final battle, with Indians on the Hydaspes, is given the full treatment, followed by Alexander's death. The term "BC" is avoided since it was thought that American audiences might not realise that years BC are counted backwards. The film was moderately successful despite being derided by critics and scholars alike.[3] Other ambitious Alexanders have not been ignored—such as Alexander Nevsky in a Russian film (*Alexander the Warrior Saint*). We have already met the Iskander film derived from Kipling.

Alexander has also been a subject for children's films. *Maya the Bee* was a German book by Waldemar Bousels of 1912. Later, this Maya is a subject for Japanese cartoon films and TV series (1978), in which she meets Alexander the Great, who is a mouse. Alexander even meets Disney's Seven Dwarfs in a fantasy by the Yugoslav J. S. Gandeto. And there is a completely cartoon book in David West's Cartoon Book Series.[4] Richie Webb's *Horrible Histories* (2009–

[3] P.C. and F. R. Greenland, *Responses to Oliver Stone's Alexander* (Madison: University of Wisconsin Press, 2009).
[4] Rob Shone and Anita Ganeri, *Alexander the Great: The Life of a King and*

2013) manages a "rock anthem" *Alexander the Great Song*, and in his *Groovy Greeks* Alexander and Hephaistion debate making a new Alexandria. W. Steig, the creator of the image of Shrek, offers an Alexander to illustrate Will Cuppy's (1884–1909) *Decline and Fall of Practically Everybody*. Some have thought that C. S. Lewis' *The Voyage of the Dawn Trader*, a children's adventure of travel to the east, was in some way affected by the Alexander story, but if so it is very well concealed. D.C. Comics' *The Haunted Tank* has the spirit of Alexander interceding for a World War II soldier.

Turning to novels. Louis Couperus (Dutch, 1863–1923) wrote an *Iskander. De roman van Alexander de Grate*. Far later, Mary Renault's trilogy is undoubtedly the finest and fullest "fictional" account of Alexander's life: *Fire from Heaven* (1969), *The Persian Boy* (1972), and *Funeral Games* (1981), as well as a biography, *The Nature of Alexander* (1975).[5] Others have tried their hands—N. Nicastro, *Empire of Ashes: A Novel of Alexander* (2010), has had mixed reviews. There is Christian Cameron's *Alexander, God of War* (2012). Richard Stoneman tells me of novels *The Alexander Cipher* by Will Adams and *Sunset Oasis* by Baha Taher, which deal with an Alexander buried at Siwa. V. Massimo Manfredi (in Italian) has published novels on *Alexandre le Grand* (narrated by Ptolemy), and his tomb, and a *Trilogia di Alexandros* on his whole life. In German Klaus

a Conqueror (Brighton: Book House, 2005) with over forty pages of cartoons; L. Gouzick, *Cartoon History of the Universe* vol.1, *From the Big Bang to Alexander the Great* (London: Penguin, 1990).

[5] She also wrote a detailed review of Lane Fox's book and N.G.L. Hammond's *Alexander the Great* in "Alexander the Greatest," *London Review of Books*, 4 June 1981, 14ff.

Mann's (1906–1949) novel *Alexander* (trans. D. Carter, foreword by Jean Cocteau, 1929) is an engaging fantasy in which at the end Alexander confesses his failure to an angel whose hands he has wounded with an arrow. In many ways it is also the most sympathetic fictional treatment with dramatic character studies of the protagonists, a major work of historical imagination, however unhistorical in detail— highly recommended. For example, among the fantasies of the east he invents what amounts to a *Belle Dame sans merci*.

In poetry, W. B. Yeats in "The Saint and the Hunchback" can have Aristotle slapping Alexander's bottom:

> I shall not cease to bless because
> I lay about me with the taws[6]
> That night and morning I may thrash
> Greek Alexander from my flesh,
> Augustus Caesar, and after these,
> That great rogue Alcibiades.

The real, that is ancient, image of Alexander is familiar to most today from its frequent appearance in films, on books, on Greek postage stamps, and as a notable blast of antiquity. On the Greek stage, to the present day, he appears often in the Turko-Greek *Karagiozis* shadow/puppet plays of the last two centuries, in a blend of Greek and eastern traditions, where he is also allowed an interlude with the Sirens.[7] He is very much the monster-slayer in such plays, echoing the themes of the eastern-derived Greek *Phyllada*, but his story is much contaminated by other eastern figures,

[6] Thongs for whipping children.
[7] Stoneman, *Life*, 142–143; Veloudis, *Alexander*, 64–68.

new to the account—a lover, Serinis; the "queen of Syria," Semiramis; touches of St. George and the Dragon. He had possibly contributed already no little to the image and story of the Byzantine Greek hero Digenes Akritas,[8] based on a real figure (died 788 AD), alleged son of a Saracen converted to Christianity by a Byzantine heiress and a vigorous defender of the Christian empire, as also to the Cretan verse epic *Erotokritos* of the seventeenth century.

The later Greek record can logically only be recounted from the start in the early nineteenth century when Alexander was used symbolically at the beginning of the Greek War of Independence, and the country, freed from the Ottoman yoke, naturally celebrated its greatest warrior of the past who had defeated easterners, despite Byron's nonchalant attitude (above).[9] In the mid-nineteenth century George Tertsetis published a lengthy epic dwelling on Alexander's marriage at Susa, and Leon Melas' popular encyclopaedic *Geostathes* included many Alexander episodes. There was a Greek translation of Racine's play; and, gorgons being a Greek invention, Drossinis featured Alexander's encounter in his *Idyllia* (1884), as did other Greeks such as Sotiris Skipis in a patriotic rhapsody *Der Unsterbliche*, and the notable poet Kazantsakis in an ode. A Greek play about him was written in 1862 but never staged. In Greek story, his sister, gorgon-like, seeks him over the seas until she meets a

[8] Veloudis, *Alexander*, 69–72. U. Moennig, "Digenes = Alexander? The Relationship between Digenes Akrites and the Byzantine Alexander Romance in Their Different Versions," in R. Beaton and D. Rick eds., *Digenes Akritas: New Approaches to Byzantine Heroic Poetry* (Publications of the Centre for Hellenic Studies, King's College London, 1993), esp. 103–115.
[9] Ibid., 48–51.

captain who tells her that he lives (see above, James Elroy Flecker's poems). The gorgon episode appears in prose by Andreas Karkavitsas in 1899, in a song by Sotiris Skipis in 1909 ("The Immortal"). And it has been a favourite subject for modern Greek poets, in Greece and Alexandria (Cavafy, Bekes), as well as a popular novel by K. Ion (1960); also for Greek school books and school plays.[10]

Here the poet Cavafy:

> We, the Alexandrians, the Antiochenes,
> The Seleucians, and the numerous
> Other Greeks of Egypt and of Syria,
> And in Media, and in Persia, and all the others,
> With their far-flung realms,
> With the nuanced policy of judicious integration,
> And the Common Greek Language
> Which we've taken as far as Bactria, as far as
> the Indians.
>
> (Cavafy, trans.)[11]

There has been a Greek "Sons and Daughters of Alexander the Great Dance Group" touring. But he lives for modern Macedonia and the Balkans too, claiming their part in the Alexander heritage. A portrait of Alexander appeared on an Albanian one *lek* coin in 1926–1931 (the reverse with him mounted), answered by a Greek 100-drachma coin in 1992 (based on the old Lysimachus coin portrait). Alexander is well represented in the region by statues including the familiar one on a leaping Bucephalus in the main square of

[10] See Yalouris, 19ff.
[11] D. Mendelson, *C. P. Cavafy, Collected Poems* (New York: Knopf, 2009), 172.

FIGURE 36. Philipoussis' shoulder.

Skopje. It is, moreover, tattooed on the shoulder of the Australian-Greek tennis champion, Philipoussis (fig. 36).

From the sublime, Terry Pratchett's "Discworld" is certainly the most involved and fully documented of all the fantasy worlds of our lifetime. He has a superman hero, Cohen ("Genghis Cohen"), who is told of one Carelinus who "wept for there were no more worlds to conquer." This sounds familiar. At the Temple of Offler in Tsort, Carelinus found a complicated knot fastening two beams together, and it was said that whoever untied it would reign over continents. He sliced through it with his sword and went on to conquer continents.[12] And it seems only fitting that the Jewish story of flying silver shields appearing at Alexander's siege of Tyre can now be taken for evidence for an early sighting of UFOs.

The lure of the name for an all-time success has lived on in music with "Alexander's Ragtime Band," a 1911 hit by Irving Berlin celebrating, it may be, "Alexander and His Clarinet," a black jazz band in New Orleans.

[12] T. Pratchett and J. Simpson, *The Folklore of Discworld* (London: Doubleday, 2008), 343–345.

IX

Fellow Travellers,
Marco Polo to TV

Unsurprisingly, many travellers have attempted to follow Alexander's footsteps, or in their account of their own Asian journeys have made a point of referring to him as their forerunner, even guide. During the Great Game, the struggle between the great powers, mainly Britain and Russia, for control of Afghanistan and surrounding territory on the Gateway to India, there were many worthies in our great man's footsteps. The American Josiah Harlan was one of the first, becoming a general of the Afghan army and allegedly obsessed by Alexander, yet he seems never directly to refer to him in his annals.[1]

Marco Polo

Alexander, as a traveller as well as conqueror of the east, naturally had many who thought to attempt the same journeys, notably the British and the Russians in the Great Game for India, via Afghanistan, and even Napoleon, for a while, let alone Flashman. Wellington had fought in India, and he had busts of Alexander and Bismarck in his rooms.

[1] B. Macintyre, *Josiah the Great* (New York: Harper Press, 2012).

The Romans' attempts to emulate Alexander and rule the east had come to nothing, beyond brief forays. But he was to be a model for later travellers, even if not much before the nineteenth century, when "in the footsteps of Alexander" becomes a fine motto. Just one earlier traveller must, however, be considered—Marco Polo.

Marco's thirteenth-century journey has been doubted by some.[2] His chronicle of it includes just five passages where Alexander is mentioned and each of them reflects what he or any traveller might have learned en route, although some are also recorded in one way or another in the Romances. This alone might support the view that the journey was historical, still doubted by some.

In chapter IV (Georgia), Marco Polo writes, "This is the country beyond which Alexander could not pass when he wished to penetrate to the region of the Ponent, because that the defile was so narrow and perilous, the sea lying on the one hand, and on the other lofty mountains impassable to horsemen. . . . Alexander caused a very strong tower to be built there, to prevent the people beyond from passing to attack him, and this got the name of the IRON GATE. This is the place that the Book of Alexander speaks of, when it tells of how he shut up the Tartars, not that they were really Tartars."

The Alexander elements here come from the Romances with reference to the major wall in the Caucasus, perhaps to

<hr/>

[2] There is a very fully annotated edition of the text in the two-volume *The Book of Ser Marco Polo*, in the third edition of 1921, translated and edited by Sir Henry Yule and with additions and further editing by Henri Cordier (London J. Murray 1921).

There are many other editions of Marco Polo, often with differing chapter-numbering depending on which edition was being used. See also R. Morosimi, "The Alexander Romance in Italy," in Zuwiyya 2011, 343–344.

the castle at Derbend, and of course to eastern threats, as from Gog and Magog. There were also, of course, ancient walls in the area, made by Sasanians and others and visible, though ruined.

In chapter XXII, Marco Polo is moving into northeastern Afghanistan, from Cobinan, and comes to a great plain in the province of Tonocain: "on [the plain] is found the Arbre Sol, which we Christians call the *Aerbre Sec*; and I will tell you what it is like. It is a tall and thick tree, having the bark on one side green and the other white; and it produces a rough husk like that of a chestnut, but without anything in it. The wood is yellow like box, and very strong, and there are no other trees near it nor within a hundred miles of it, except on one side, where you find trees within about ten miles' distance. And there, the people of the country tell you, was fought the battle between Alexander and King Darius."

The topography is very uncertain, also its relationship to either Alexander's battles or the defeat and flight of Darius, but the *arbre sec* has a long record. It was an oriental plane tree, which could grow to 30m and earned the title Minaret. It could speak, and, they said, it told Alexander about his coming death. Some versions have a pair of trees, of the Sun and Moon. That there was some such famous solitary tree (or trees) seems certain.

In chapter XXVII, Marco Polo writes, "Balkh is a noble city. . . . The people of this city tell that it was here that Alexander took to wife the daughter of Darius."

Balkh remains a massive and impressive ruin. The marriage, to Roxane, an alleged daughter of Darius, is located here rather than at Persepolis.

In chapter XXIX, Marco Polo writes, "Badashan is a province inhabited by people who worship Mahommet and

have a peculiar language. It forms a very great kingdom, and the royalty is hereditary. All those of the royal blood are descended from King Alexander and the daughter of King Darius (Roxane), who was Lord of the vast Empire of Persia. And all these kings call themselves ZULCARNIAIN, which is as much to say *Alexander*, and this out of regard for Alexander the Great."

Badakshan is a northeastern province of Afghanistan and an area in which many have claimed to find genetic traces of Greek blood (i.e., of Alexander, or rather of Greeks settled there). "Zulcarniain" is "two-horned." In the same chapter (XXIX):

> It [Badakshan] produces numbers of excellent horses, remarkable for their speed. They are not shod at all, although constantly used in mountainous country, and on very bad roads. And Messer Marco was told that not long ago they possessed in that province a breed of horses from the strain of Alexander's horse Bucephalus, all of which had from their birth a particular mark on their forehead. This breed was entirely in the hands of an uncle of the king's; and in consequence of his refusal to let the king have any of them, the latter put him to death. The widow then, in despite, destroyed the whole breed, and it is now extinct.

Yule's commentary on Marco Polo tells us that the Kataghan breed of horses from Badakshan has still a high reputation. One recalls also perhaps the fire-breathing "divine" horses of nearby Ferghana, which the Chinese sought out in the second century BC and which may be figured in first-century AD gold reliefs from Tillya Tepe to the west of

Balkh.[3] The horses of Turkmenistan—the Akhal-Teke horses—have long been famous for their speed.

Modern Travellers

In modern times travellers were drawn to the east for its own sake as well as Alexander's, but he is not to be easily escaped.[4]

The great historian Arnold Toynbee held that the history of a place cannot be understood without also understanding its environment and that this must be experienced at first hand. In *Between Oxus and Jumna* (1961) he travels Afghanistan and some neighbouring areas with several references to Alexander, and a clear but well-founded prejudice in favour of the Indo-Greeks. But Toynbee had a great imagination too, and in his *Essays* he offers a speculative account of what Macedonians might have done. If Philip had survived assassination, he would have killed Alexander, gone west to Italy, deported the population of Rome to Gaul, and made Rome a Macedonian colony. Carthage would have been destroyed. There would have been Italians in his army against Persia, but he would not go beyond the Euphrates. Egypt would have been left free, and there would have been a variety of World Empire, its capital at Alexandria. But in truth, "He

[3] J. Boardman in *Afghanistan* (ed. J. Aruz, E. V. Fino, 2012), 110–111. And see above, p. 52. There has been speculation whether the Chinese-invented crossbow could have been a match for Alexander's cavalry and spears.

[4] Aurel Stein, *On Alexander's Track to the Indus* (London: Macmillan, 1929); P. Tuson, *Western Women Travelling East, 1716–1916* (Oxford: Arcadian Books, Oxford University Press, 2014). The women travellers were generally more concerned with recording contemporary life than antiquity, it seems.

[Alexander] had vastly expanded the area of the Hellenic World by annexing to it the Persian Empire's domain bodily. But, at his death, this expanded Hellenic World relapsed into the anarchy in which the smaller pre-Alexandrine Hellenic World had been living before 338 BC, the year in which Philip II had set up the League of Corinth."[5] "He sought to hold the Hellenic World together and at the same time to enlarge its geographical extension enormously by conquering and incorporating the Persian Empire. After Alexander's sudden premature death in 323 BC the expanded Hellenic World relapsed into political disunity and consequently resumed its fratricidal warfare—now on a far larger scale."[6]

On the ground, in *Alexander's Path* (1958), Freya Stark gives a very detailed account of retracing Alexander's steps in Anatolia with a lot of shrewd comment and reference to ancient sources—in effect a scholarly commentary as well as an engaging story. Michael Wood made a serious attempt to follow Alexander in his 1997/1998 TV series, *In the Footsteps of Alexander*, which offers excellent views of the terrain covered, at least so far as it was then accessible, and a reasonable account of his achievements and difficulties. The narrative was published by the BBC in an excellently illustrated book of the same title in 1997. John Prevas' *Envy of the Gods* (2004) follows Alexander's route carefully and likens his invasion of Asia to Genghis Khan's ruthless invasion of the west.

[5] A. Toynbee, *Mankind and Mother Earth* (Oxford: Oxford University Press, 1976), 199.
[6] A. Toynbee, *The Greeks and Their Heritages* (Oxford: Oxford University Press, 1981), 67. This too is the spirit of J. D. Grainger, *Alexander, the Great Failure* (London: Hambledon Continuum, 2007).

Other films, for the TV or cinema, have used Alexander as an excuse for exploration in Central Asia: *Alexander's Lost World* is a TV film (David Adams Films) of 2013 with an Australian explorer convincingly tracing the source of the River Oxus.

Envoi

"And so we say farewell . . ." in the words of early film travelogues. But the journey is incomplete, and I daily find references to works or images that I cannot find, or subjects to which I wish I had devoted even more time—Amazons, China. I leave these further challenges for the reader to explore and enjoy, and for the scholar to explain.

And if Alexander—in Hades or on the Islands of the Blessed—reads this, does he laugh or weep?

Index

Page numbers in **boldface** refer to illustrations.